FURR

PORTRAIT OF THE
SUSSEX WEALD

A WOODLAND LEGACY

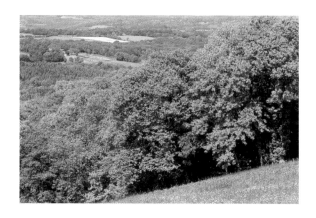

IAIN McGOWAN

HALSGROVE

First published in Great Britain in 2009

Title page: *The essence of the Sussex Weald – a woodland landscape near Brightling.*

British Library Cataloguing-in-Publication Data
A CIP record for this title is available from the British Library

ISBN 978 1 84114 897 7

HALSGROVE
Halsgrove House,
Ryelands Industrial Estate,
Bagley Road, Wellington, Somerset TA21 9PZ
Tel: 01823 653777 Fax: 01823 216796
email: sales@halsgrove.com

Part of the Halsgrove group of companies
Information on all Halsgrove titles is available at: www.halsgrove.com

Printed and bound by Grafiche Flaminia, Italy

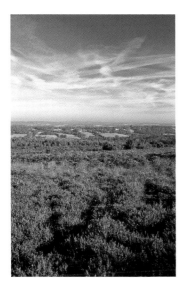

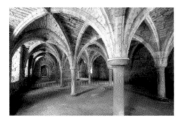

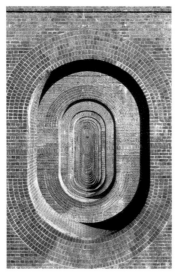

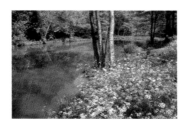

CONTENTS

MAP OF SUSSEX

SURREY

KENT

HAMPSHIRE

Crawley •

East Grinstead •

High Weald

Horsham •

Crowborough •

Haywards Heath •

R. Rother

Chithurst •

Petworth

R. Arun

Low Weald

R. Adur

R. Rother

Romney Marsh

Battle •

Rye

LEWES •

R. Ouse

R. Cuckmere

Cooden

Pevensey •

HASTINGS

CHICHESTER •

WORTHING

BRIGHTON

EASTBOURNE

HIGH WEALD
LOW WEALD
Wealden Greensand Escarpment
South Downs
Coastal Plain
Order of book
Wealden locations

N

0 10 20 30 km

INTRODUCTION

The Sussex Weald spans the northern half of the county, a region once outstandingly rich in ancient woodlands and coppice interrupted by areas of open heathland, commons and small fields. To the north and east and extending into parts of Kent and Surrey, the hilly High Weald, mainly on varying sandstone formations, reaches up to 240m at Crowborough Beacon in a series of long, often parallel, ridges spaced out by distinctive, narrow, steep-sided valleys (ghylls). To the south stretching almost to the chalk Downs lies the gently undulating comparatively flat Low Weald, its western extremity hemmed in by a discontinuous escarpment of rising greensand and gault and to the east by the grazing marshland of Pevensey Levels adjoining the English Channel. Despite tremendous demands on land in Southern England for new housing and industry, a distant view across much of the Wealden landscape still gives the impression of almost unbroken woodland. It is this aspect of a forest barrier coupled with its generally miry, moisture retentive soils and resulting inaccessibility that have given the Sussex Weald its notable character and history.

At the end of the ice age as Europe's landmass started to warm, great forests began to appear, proliferating south across the English Channel and deep into France and Germany. In Sussex and in the Weald in particular, this wide ranging primeval forest was almost impenetrable, only the hardiest of settlers migrating northwards making an impression on its dense tree canopies and nutritionally deficient soil. For centuries the area simply became a pioneering region of small clearances between wood and wasteland. As the years of the Romans, Saxons and Normans came and went, the Wealden settlers suffered fluctuating fortunes between the advance and retreat of civilization principally due to pressures of population, economic conditions and the sheer difficulties of their chosen surroundings. Even as late as the thirteenth to fourteenth centuries, the area in part was principally a tree covered waste in a state of both physical and cultural isolation from the remainder of Sussex.

From the early Tudor period onwards, two principal factors started a succession of changes to the Wealden environment. Firstly the requirement for timber and particularly Sussex Oak in England's increasing Naval fleets and to a lesser extent in domestic construction and secondly the need for fuel in the growing Wealden iron industry. For centuries the Wealden clays had been worked in a primitive fashion for iron ore, the Sussex iron being made by simple bloomery processes but towards the end of the fifteenth century these methods changed drastically with the introduction of the blast furnace. The use of furnaces fuelled by abundant supplies of Wealden timber and with their bellows and associated forge hammers driven by water power from dammed up streams in the deep Wealden ghylls transformed many parts of the region. This in turn established the Sussex ironworks as the leading cast iron producers in the country during the first half of the sixteenth century. Iron was used to an increasing extent for small arms, cannon, shipbuilding, domestic construction, firebacks, etc and it was not until the more efficient development of the industry, near the newly discovered coalfields in other parts of the country, that the Sussex furnaces and forges started to close, the last being at Ashburnham in the 1820s.

The principal effects of this industrial evolution were the abrupt and widespread depletion of tree cover in several locations within the Weald and the subsequent growth of communications, initially by improvements to the harbours and upper reaches of the county's principal rivers and later new canal construction. Very slowly the Wealden environment emerged from its state of seclusion and underdeveloped character. Methods of tillage were changing, old enclosures were being improved by burning, liming and marling and farmhouses modernised. Field areas were increasing and the landscape reshaped to more of the appearance that we can see today. During the early years of the nineteenth century with the growing science of road making, the old clay tracks of the Weald, generally reduced to a quagmire in the rainy seasons (an old rhyme credits 'Sowseks' with 'dirt and myre') were at long last improved and with the final coming of the railways the opening up of the Weald was complete.

In present times, the Weald is now looked upon as one of the great secrets of Southern England and for many one of the most distinctive and beautiful small scale landscapes in Britain. The area still contains an extremely high percentage of forest enhanced and supplemented by wide strips of residual woodland (shaws) bordering the relatively small fields. Many of the High Wealden valleys are still clothed with broad shouldered trees which fill every hollow whilst scattered across this historic landscape and along its often steeply banked lanes is one of the highest densities of timber-framed medieval houses in Europe. To discover the Weald is to undertake a journey, ideally by foot along its numerous, often unused footpaths to a world of extensive woodland, dark silent pools and the occasional hazy glimpse of a distant ridge or the South Downs. There are no mountains in 'The Wonderful Weald', no dramatic river valleys or scenic wonders, just the quiet beauty of one of the most historic regions in the country where moated manor houses, weatherboarded or tile-hung cottages, shingled spires and archaeological remains of the old iron or glass industries can still be found in considerable profusion. In the finish perhaps that great Sussex writer and poet Rudyard Kipling should have the final word on the Sussex Weald. As he wrote in his 'Puck's Song':

See you the ferny ride that steals
into the Oakwoods far?
O that was whence they hewed the keels
That rolled to Trafalgar,

And mark you where the ivy clings
to Bayham's mouldering walls?
O there we cast the stout railings
That stand around St Pauls.

See you the dimpled track that runs
All hollow through the wheat?
O that was where they hauled the guns
That smote King Philip's fleet.

(Out of the Weald, the secret Weald,
Men sent in ancient years.
The horseshoes red at Flodden Field,
The arrows at Poitiers!)

See you our stilly woods of Oak
and the dread ditch beside?
O that was where the Saxons broke
On the day that Harold died.

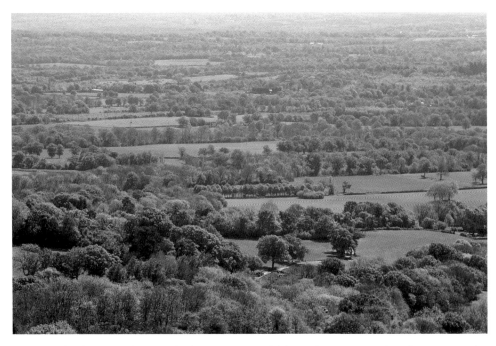

The view looking south towards the Sussex Weald from the 294m Leith Hill in Surrey, the highest point in southeast England. John Dennis writing in 'Original Letters' of 1721 described the scene, "I saw a sight that would transport a stoic ... beneath us lay, open to our view, all the wilds of Surrey and Sussex together with a greater part of Kent, admirably diversified in every part, woods, fields of corn and pastures everywhere adorned with stately rows of trees."

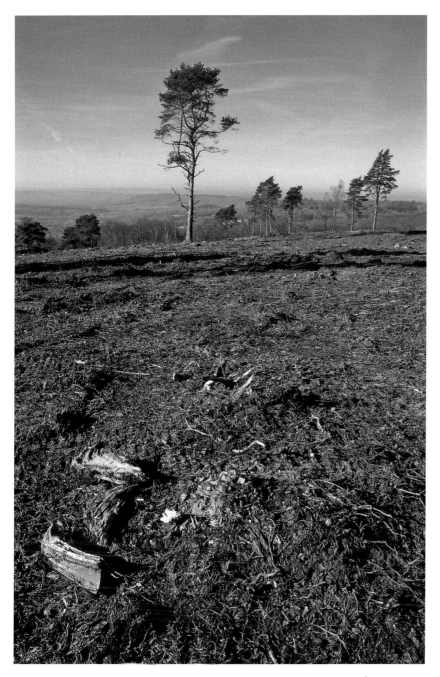

Tree and shrub management on Blackdown. From this lofty sandstone ridge at the western end of the Weald, there are extensive views overlooking much of the Weald and South Downs and which particularly illustrate the degree of woodland still surviving. Blackdown's summit at 280m is the highest in Sussex, a place much favoured by Alfred, Lord Tennyson who lived nearby at Aldsworth House. The Lower Greensand conditions on Blackdown support trees and plants favouring dry acidic soil, examples including gorse, heather, bilberry, scots pine, silver birch, oak and whitebeam.

TOWARDS THE WEALD
A Downland View

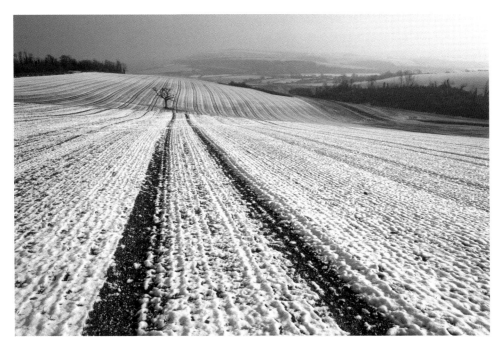

A wintry scene from Bury Hill looking down towards the Arun Valley and its approaches to the West Sussex Low Weald.

The very nature of the Sussex Weald, a landscape in part surrounded by higher hills and the North and South Downs ensures long distant views to within its heartland. From these peripheral high points and crests the often wooded mosaic of the region becomes immediately apparent. In addition the not uncommon blue haze which can dim its farthest outlines gives the Weald an extraordinary sense of mystery, fitting perhaps for the least known part of Sussex. This first brief chapter with photographs taken mainly along the southern downland flank of the Weald sets the scene for the later more detailed study of the area itself.

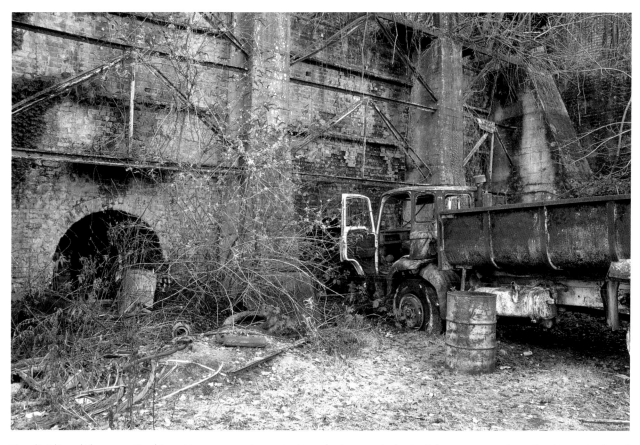

Derelict lime kilns near Cocking. Lime was an important product not only for building purposes but also for agricultural use and in particular for breaking down the heavy Wealden lime-deficient clays. It was only after the opening up of communications by land and water to the Weald in the latter years of the eighteenth century and subsequent improved husbandry of the old enclosures by liming or marling that generated the Wealden small-scale patchwork of fields and woodland seen today. Remains of many old lime kilns and their associated chalk quarries can still be found along much of the South Downs. As early as 1715 there is mention of isolated lime kilns at Cocking but the nearby lime works, shown here, originate from 1906 operating continuously until their closure in 1999.

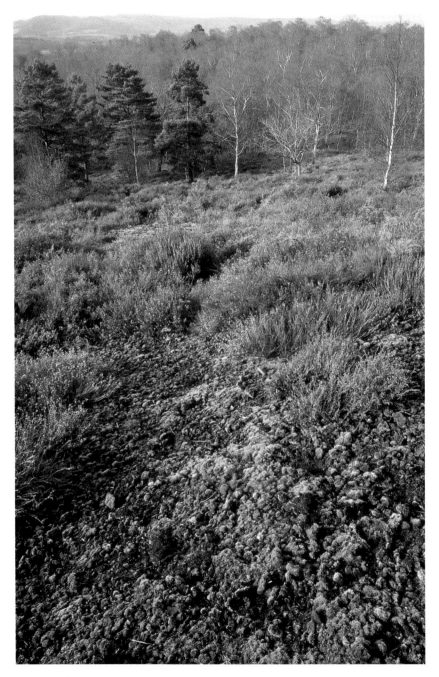

Hesworth Common near Fittleworth. This scene is typical of much of the open woodland and Greensand heathland found in the western hill country which borders the northern scarp slope of the South Downs and the Low Weald.

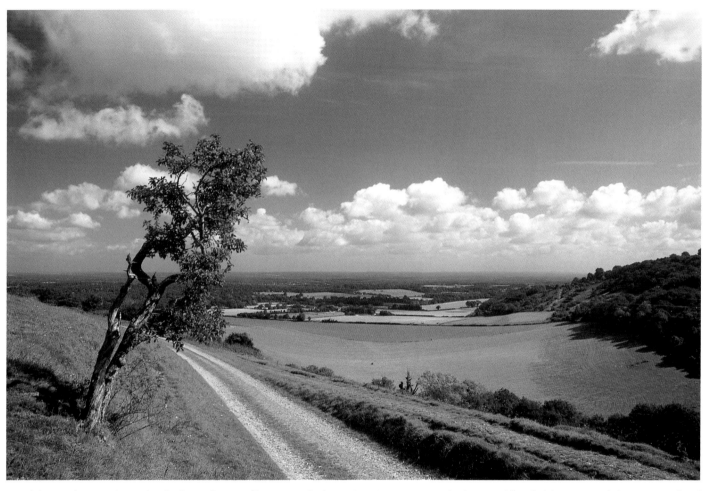

An old Bostal or trackway leads down from Sullington Hill above Storrington towards the Wealden fields. Many of these Downland tracks date back to ancient times and are possibly the oldest of all human features in Sussex created over several millennia by the action of cart wheels and tramping of feet.

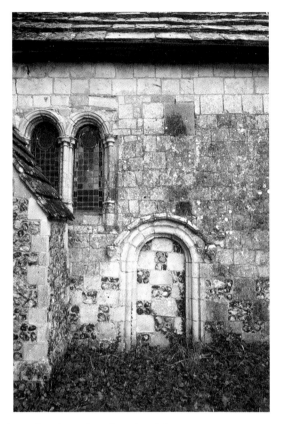

Doorway and window detail at the church of St Peter at Upper Beeding. The present thirteenth century church, later much restored, probably formed part of the Benedictine Priory of Sele founded originally by William de Braose here in 1075. The priory, an example of early monastic settlement on the edge of the Weald, was mainly sited to the north of the church but now buried under adjoining housing.

This doorway and window built into the south wall of the chancel almost certainly came from one of the original priory buildings becoming therefore the oldest surviving fragments of the monastic foundation. Upper Beeding's earlier local importance was its site as the lowest bridging point of the River Adur and as a crossroads of the great east-west route through Southern England from Canterbury to Southampton and north-south to the coast.

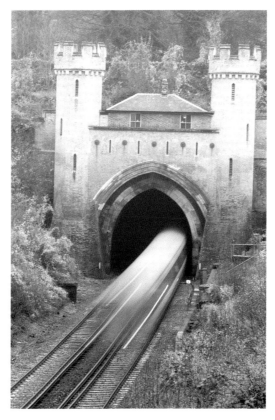

Clayton railway tunnel. Acting as a gateway from the Weald to Brighton, this unique castellated railway tunnel entrance is situated on the main London to Brighton railway line at the northern end of Clayton Tunnel where the railway passes under the South Downs. Opened in 1841 as part of the London, Brighton and South Coast Railway, the tunnel was for a short period lit by gas, no doubt to reassure nervous passengers in open third class carriages that all was safe and secure in their 2072m journey under the chalk hills. The cottage between the two battlemented turrets was added later.

Opposite: Looking north from the slopes of Ditchling Beacon, inland across the Weald. At 248m, the beacon is the highest point in East Sussex and was one of the sites where fires were lit to warn of the Armada four centuries ago. The earthwork remains of an Iron Age hillfort surround the beacon with magnificent views in all directions. The village of Ditchling can be seen in the distance.

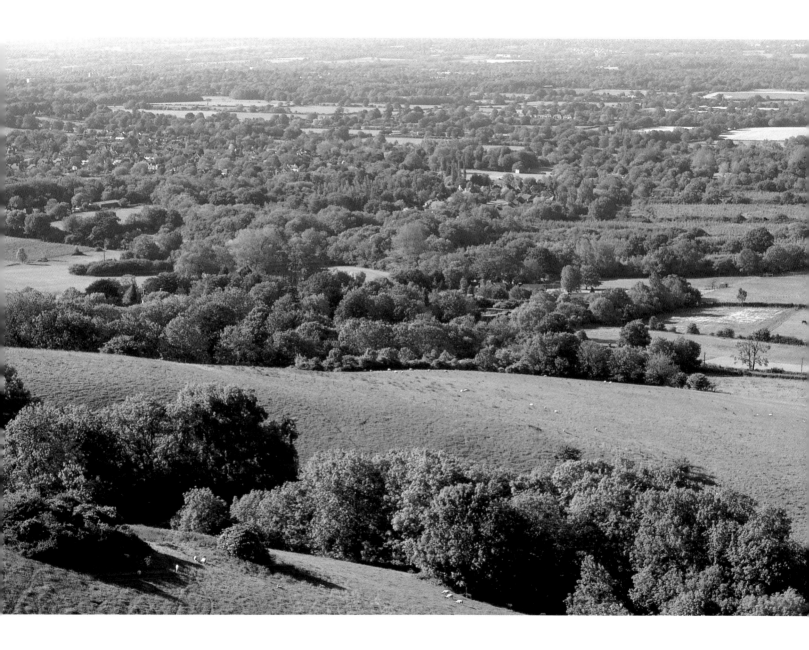

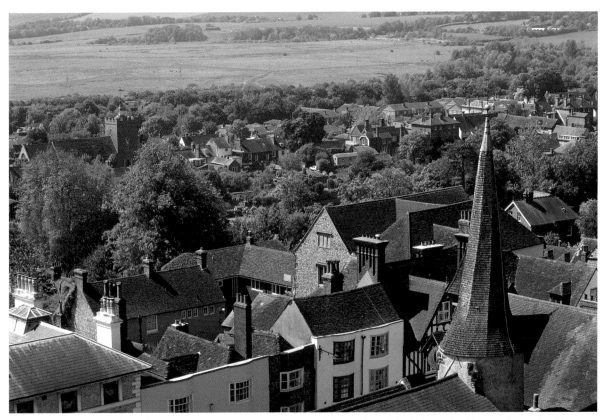

Lewes. The view looking down over the town's rooftops and the spire of St Michael's Church from the Norman remains of Lewes Castle. Now the county town of East Sussex, Lewes is located in a strategic position mainly on a spur of the Downs above the River Ouse which flows through a narrowing gap in the hills on its way from the Weald to the sea. An ancient borough and port for many centuries, the town is now an important administration centre and notable for its variety of period architecture. The river was once a vital means of communication and trade access and on which much local prosperity depended. Wealden iron and timber would be sent down river to the port of Newhaven whilst more general groceries, textiles, spices etc were shipped north.

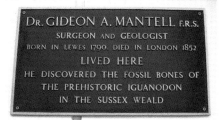

Left: A plaque to the Lewes physician Dr Gideon Mantell who practised medicine in the town and was noted for his study of Wealden geology.

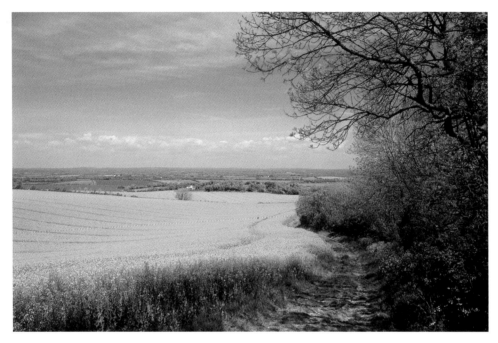

A crop of oilseed rape on the edge of the Downs merges with the East Sussex Low Wealden fields near Alciston.

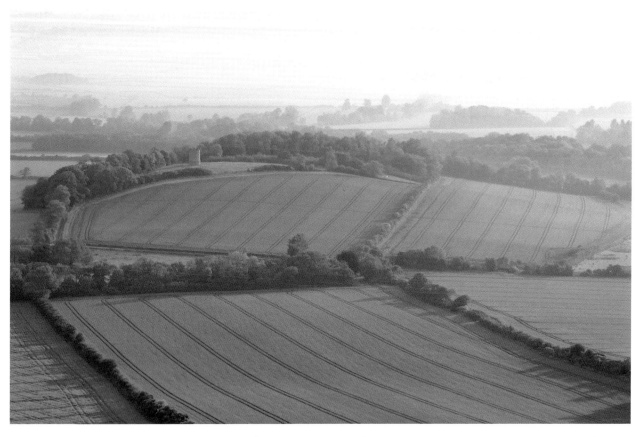

Mist hangs over the fields below the 219m Firle Beacon on an early summer's morning. The prominent round tower on the left of the photograph was built in 1819 by the fourth Viscount Gage for his gamekeeper of the Firle Estate.

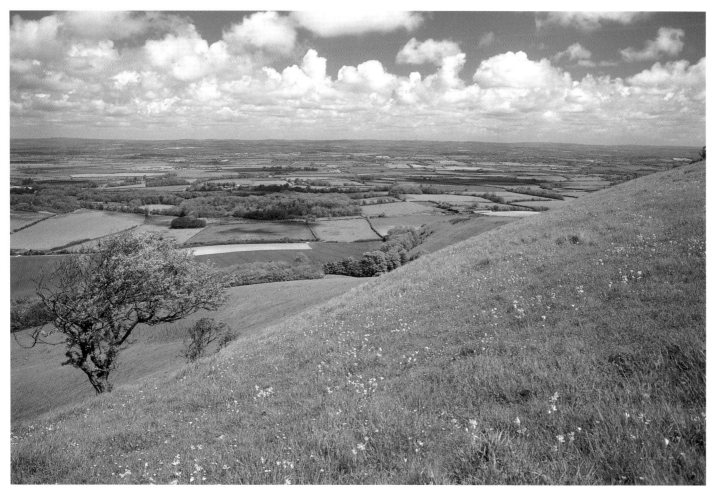

A glorious spring day on the Downs near Firle Beacon looking inland towards Charleston Farm and Kipling's 'wooded dim blue goodness of the Weald!' The Low Wealden fields near Ripe and Chalvington fade away to the misty outline of Crowborough Beacon and Ashdown Forest in the extreme distance – the very heart of the Sussex High Weald.

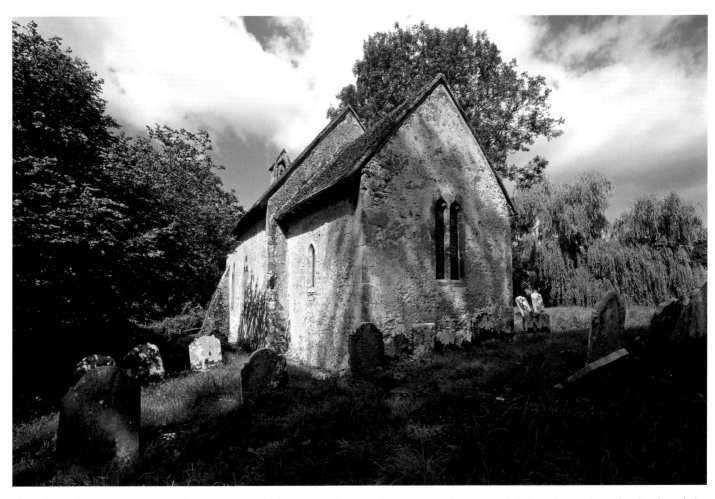

The eleventh century church of St Mary at Chithurst, stands on a knoll, possibly a pre-christian site, above the banks of the River Rother. This tiny and simplest of churches has changed little over an entire millennium and Pevsner quotes "that poverty or remoteness have kept the original dimensions intact without any kind of addition". The hamlet of Chithurst is situated near the very western extremity of the Low Weald where the Wealden clays form a basin within the encircling Greensand region. Increasingly known as the 'Western Weald', this area of pasture land almost entirely surrounded by tree clad hills has its own highly distinctive character.

THE LOW WEALD

Chithurst to Cooden

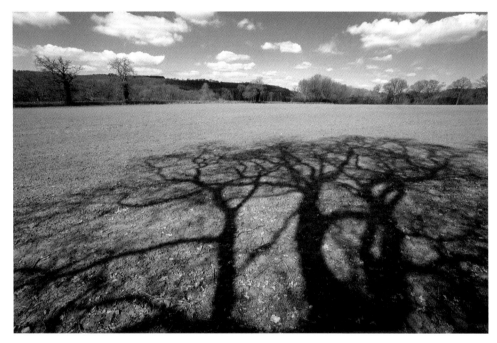

Tree shadows creep across the winter fields below Linchmere.

The Low Weald spans a considerable length of Sussex, flanked in the west and north west by the discontinuous escarpment of hilly country developed on rocks of Greensand and Gault clay and by the Surrey boundary. It then slowly tapers through the county to reach the coast midway between Eastbourne and Bexhill. To the south lie the South Downs fringed by further narrowing bands of Greensand and Gault whilst to the north the ground slowly rises to the High Weald. Almost all of this area is gently undulating but at its eastern extremity the land is totally flat particularly behind the coast at the Pevensey levels, now a major tract of grazing marshland. Once densely forested, the Low Weald has been much cleared for agriculture although in the west many coppice woods and wood pastures still remain.

Shulbrede Priory near Linchmere, close to the Surrey border, was founded at the turn of the thirteenth century for five canons of the Augustinian order. After the Dissolution it became a farm and at the beginning of the twentieth century was converted and lovingly restored into a private home by the MP Arthur Ponsonby and his wife Dorothea, daughter of the composer Hubert Parry. One of the building's best known features is the series of sixteenth-century wall paintings showing ladies in Elizabethan costumes and animals celebrating the Nativity.

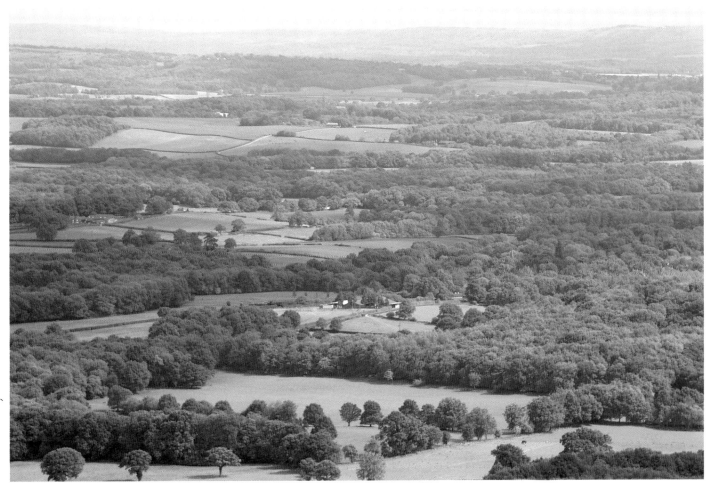

Another view from the summit of Blackdown overlooking a part of the 'Western Weald' with the ridge of the South Downs in the far distance.

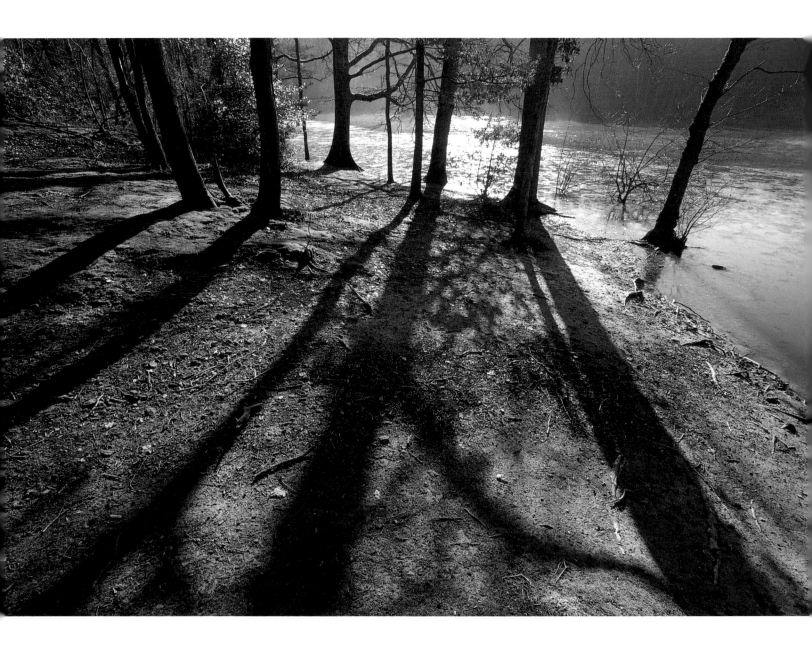

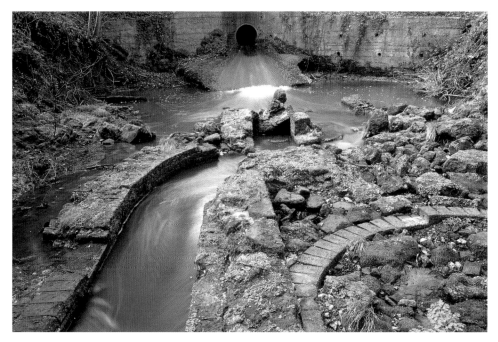

Foundations and surviving masonry of the wheel pits, tail race and other elements of the ironworks can still be clearly seen below the pond bay and the whole site is now regarded as one of the best preserved of its type in south-east England. The furnace, associated bellows and casting pit were close to the wheel pits and the entire complex is thought to date back to the latter years of the sixteenth century although the first specific reference is dated 1614. By 1777 it is recorded that all industry had ceased here.

Opposite: The low winter light casts shadows around the edge of the semi-frozen Furnace Pond near Fernhurst. Occupying an area of some 1.5ha, the pond was originally formed by a dammed-up stream to power the adjacent Fernhurst or North Park Ironworks. The dam or 'pond bay' can still be seen pierced by two sluices. Around the immediate area mounds of slag and the names of Furnace Wood and Minepit Copse all attest to the industry once located here. Ponds such as this, generally known as Hammer Ponds, are the most distinctive remaining evidence of the iron industry in Sussex. In some cases they would have been constructed in a series along the often deep wooded valleys to provide a more reliable flow to power the furnace bellows and forge hammers.

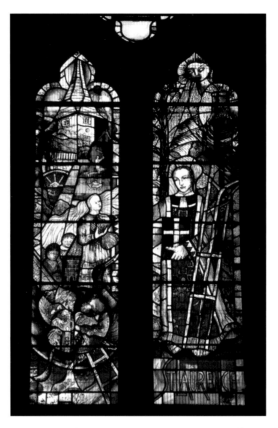

The Millennium Window at the Church of St Laurence, Lurgashall. Until 2000 the eleventh century Church of St Laurence had no stained glass windows depicting its patron saint. The artist Philippa Martin was therefore commissioned to create a window not only celebrating the new millennium but also to represent St Laurence and village life through the ages. Amongst the features shown are the church with its ancient yew tree, St Laurence himself with his robe decorated in stylized flames symbolising his martyrdom, a three-tiered golden goose representing Noah's Ark – the name of the village pub, cricket being played on the village green, an overshot water mill and a glass blower with medieval furnace and bottles – a reference to the glassmaking in the area in the Middle Ages. The village of Lurgashall immediately below Blackdown with its beautiful sloping triangular green is often regarded as one of the finest in West Sussex.

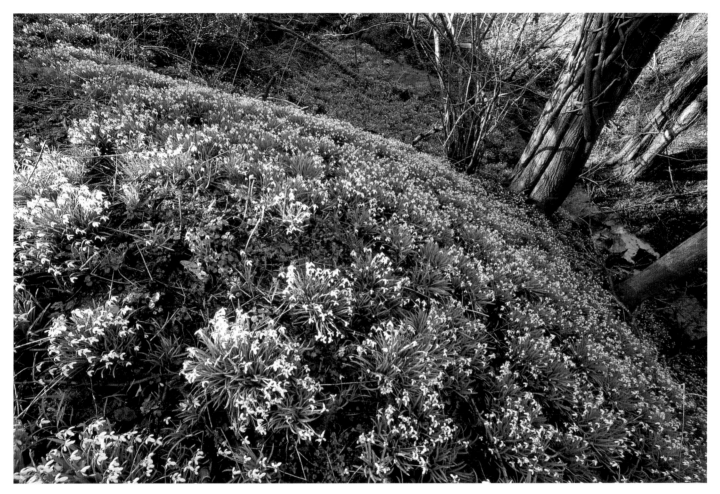

Snowdrops grow in profusion on the site of another ironworks, long since abandoned, in Frith Wood near Northchapel. The rusty colour of the small stream below the flower-covered bank is a strong indicator of the presence of iron.

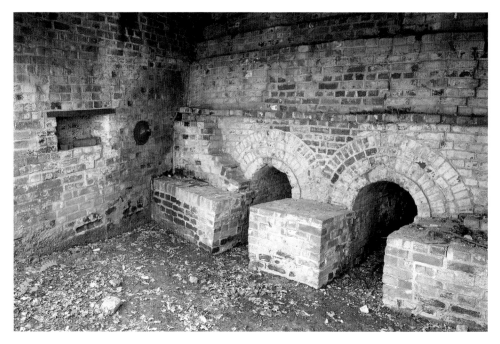

Part of the restored kiln at Ebernoe Brickworks within the woods of Ebernoe Common. Bricks were made here from the late seventeenth century using locally dug clay and the kiln is an unusual survival of a brickworks from this period having never been altered or mechanised. The kiln would have held up to 18000 bricks when loaded and fired through the twin stoke holes shown in the photograph. The works went out of use in the 1930s but the site with its kiln and moulding shed is now a scheduled ancient monument owned by the Sussex Trust for Nature Conservation. Ebernoe Common is one of the most important areas in Britain for its woodland and has a long tradition of local people with commoners rights using the woods. As with so many other Wealden locations, an ironworks also operated here during the 1500s. Apart from its wealth of ancient trees, rare flowers, lichens, mosses, liverworts and fungi, it is an outstanding site for bats with most British species living in the vicinity. The Common is now designated as a National Nature Reserve and Site of Special Scientific Interest.

Opposite: The view looking towards the upper reaches of the River Arun from near Harwoods Green above Stopham. Once a busy waterway, the river was the only one in Sussex suitable for barges to navigate any significant distance into the Weald until the early years of the eighteenth century. By the end of the same century improvements to the course of the river and the later opening of the Wey and Arun Junction Canal in 1816 allowed further trade access to these rural locations.

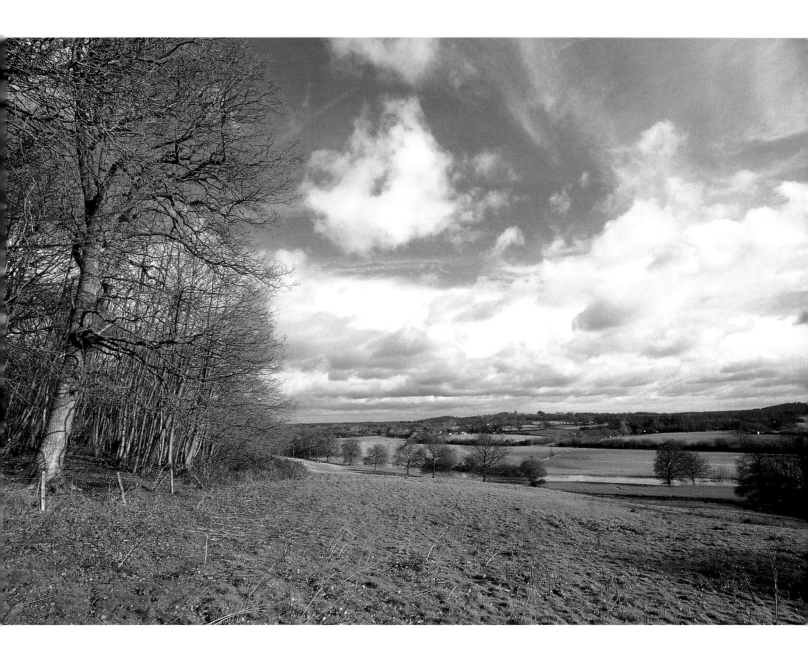

Harwoods Green, simply a farm and a few cottages near the west bank of the River Arun amongst the trees and fields below the hilly country of Fittleworth Wood and Bedham.

Winter sunshine in Chance Copse near Harwoods Green. The practice of coppicing has probably been carried out in the Weald for over a thousand years. Hazel and Sweet Chestnut when cut down to a stump close to the ground throw out rapidly growing multiple shoots, the stems of which can then be cut on a fourteen to twenty year cycle to provide fuel in the form of charcoal or for small timber products such as spars, fencing, hurdles, wattles, etc. This form of working woodland was particularly prolific in parts of West Sussex where many former coppices still survive.

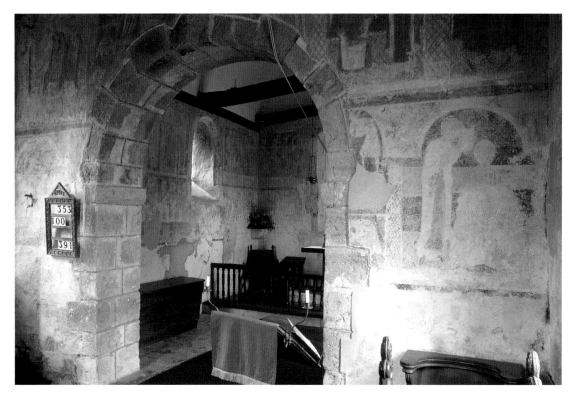

Wall paintings, the church of St Botolph, Hardham. Within the small, almost unaltered, eleventh century church of St Botolph just south of Pulborough can be found the earliest nearly complete series of wall paintings in the country. Dating from shortly after 1100 AD and forming a decoration to both nave and chancel, the paintings were totally covered with plaster in the thirteenth century only to be finally rediscovered from 1866 onwards and subsequently treated with the best preservatives at any given time of exposure. In places the paintings have faded considerably with much loss of detail but the scenes portrayed are nevertheless now rare treasured survivors of Norman art.

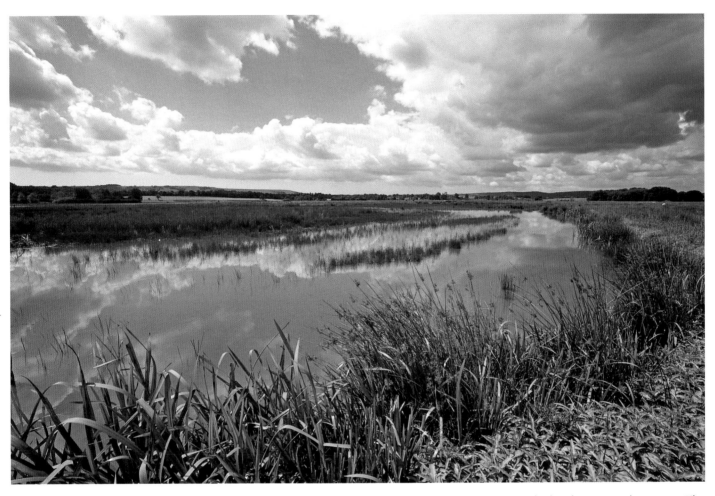

Looking across the flooded Arun Valley near the RSPB Pulborough Brooks Nature Reserve towards the distant South Downs. The reserve, a lowland wet grass habitat, is particularly well known for the thousands of wild ducks and water birds to be found in the autumn and winter months. With its considerable series of listed events throughout the year it has become a popular destination for ornithologists, walkers and other visitors simply wishing to enjoy the sights and sounds and wide open space of this interesting and beautiful venue.

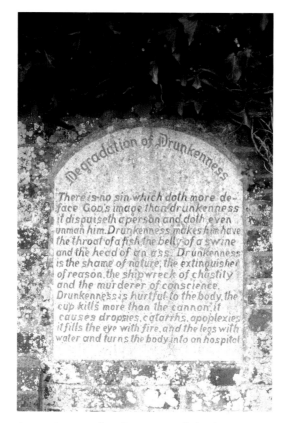

A warning to all pub-goers and drinkers, to be found at Kirdford near Wisborough Green.

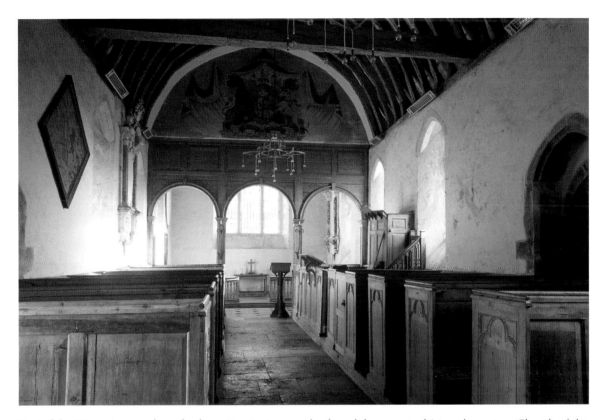

East of the River Arun and not far from Storrington can be found the remote thirteenth-century Church of the Holy Sepulchre at Warminghurst with just a single farmhouse for company. Now in the care of the Churches Conservation Trust, its relatively plain exterior hides a remarkably unspoiled interior.

Dividing the nave and chancel is a three-arch timber screen of about 1700 with a painting of the royal coat of arms of Queen Anne above, with surrounding drapery. Adjacent to the screen, the nave is filled with eighteenth-century pine box pews, a three-decker pulpit and clerk's desk with an enormous clerk's chair. The clear glass windows, uneven flagstone floor and memorials to the Butler and Shelley families complete this harmonious and memorable scene.

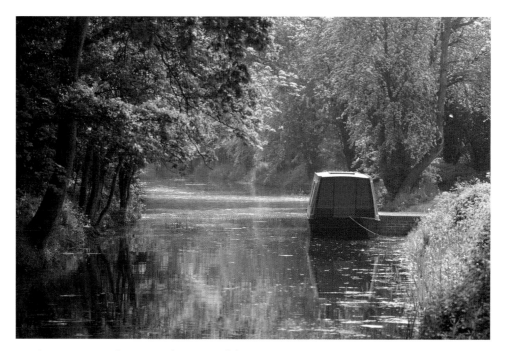

A sylvan scene on the restored section of the Wey & Arun Canal near Loxwood. Originally built in two stages as the Arun Navigation and Wey and Arun Junction Canal, and completed in 1816, the canal acted as a link from Surrey to the English Channel. Coupled with the later opening of the Arundel and Portsmouth Canal completed in 1823, the combination of canal and river enabled a continuous line of navigation to be used between London and Portsmouth and later to be known as 'London's lost route to the sea'. As with many similar schemes, after modestly trading for some fifty years, the coming of the railways heralded a decline in the canal's fortunes with final closure in the latter half of the nineteenth century. The Wey & Arun Canal Society was founded in 1970 to restore the waterway and to date much of the canal has been cleared, several miles have been reopened with associated restoration of locks, bridges and aqueducts.

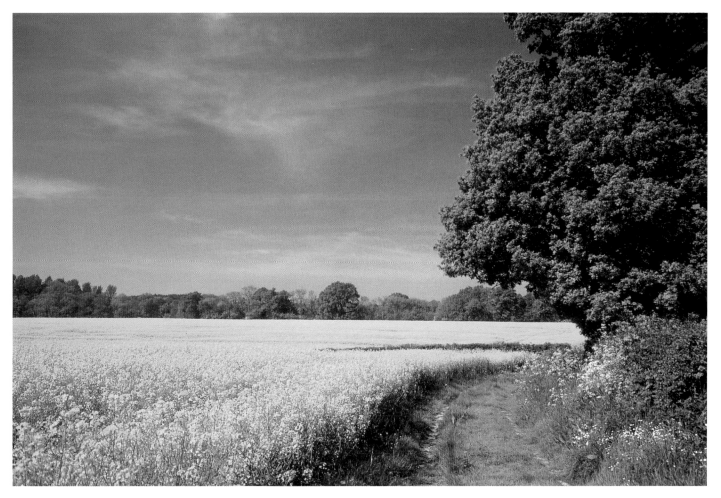

A glorious spring day in the Low Wealden countryside near Loxwood.

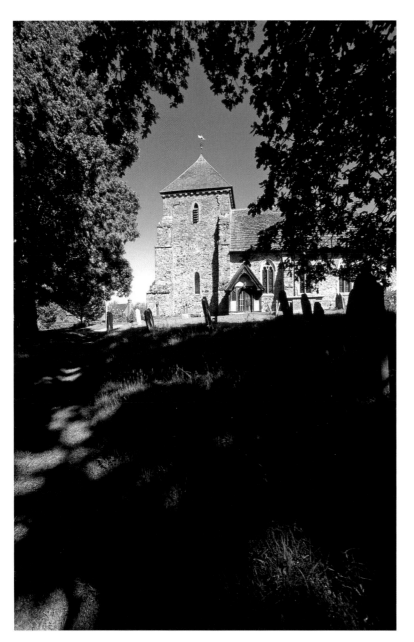

The Church of the Holy Trinity at the village of Rudgwick in its hilltop setting literally just a few metres from the Surrey border with in the words of E V Lucas "the most comfortable looking church tower in Sussex". Rudgwick, often called 'Ridgick' by older residents was, according to one source, also known as 'the place where they sell fat pigs on Sundays'.

Opposite: Part of the beautiful sequestered churchyard of St Nicholas at Itchingfield. Situated at the end of a short cottage-lined street, the twelfth-century church and its surroundings exude an atmosphere of utter peace. The church is notable for its unusual timber framed tower and belfry containing four massive posts, pegged bracing, shingles and vertical weatherboarding all added to the building in the fifteenth century. Within the churchyard is the unique toy-like half-timbered priest's house also dating back to the fifteenth century and probably used as a temporary lodging for travelling monks from Sele Priory.

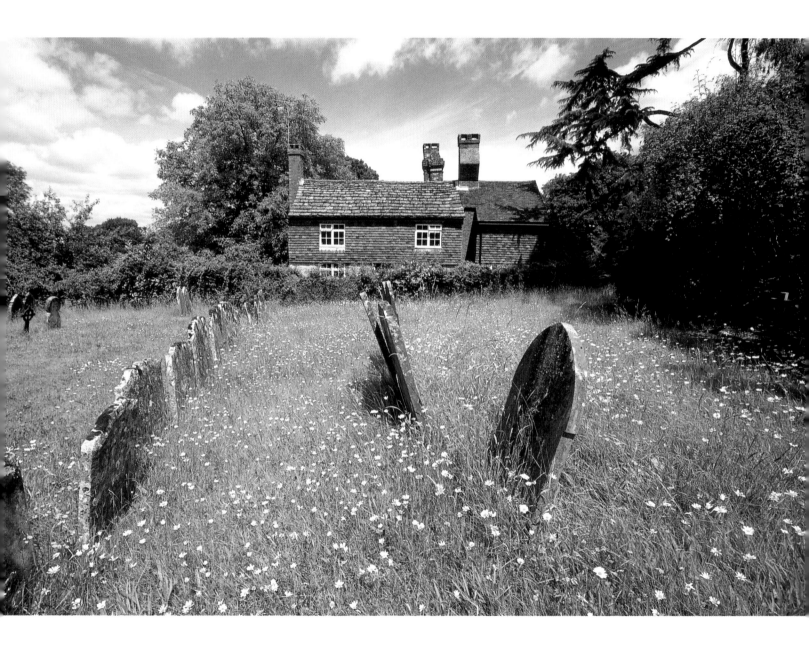

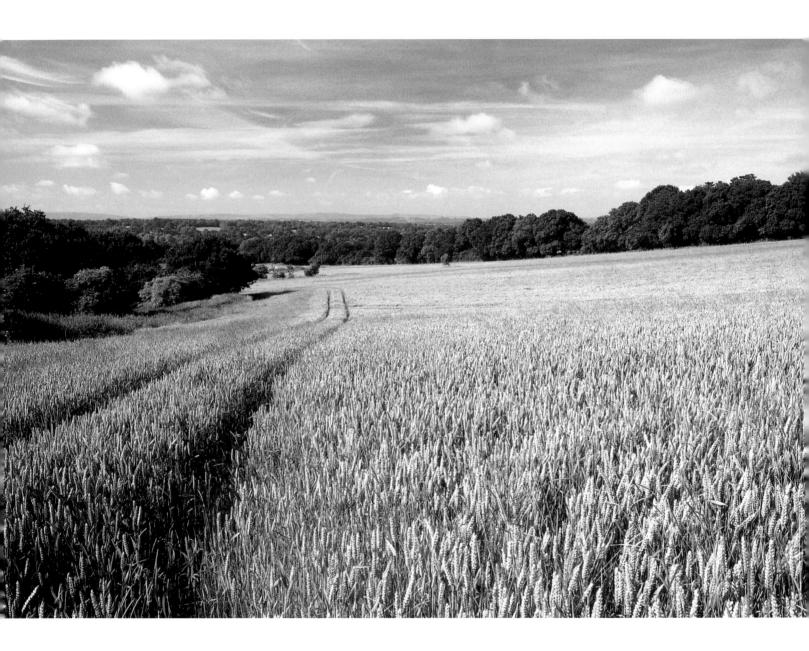

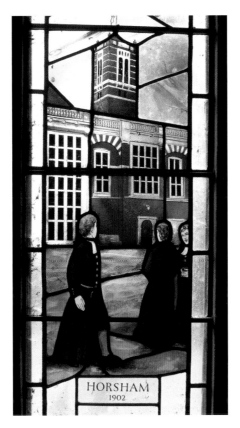

The Bluecoat school of Christ's Hospital originally founded by Edward VI in 1553 at Newgate, London was moved to its present site at Stammerham west of Horsham in 1902. With its distinctive red brick buildings and its pupils historic and striking uniform, the school, affectionately known as 'CH', has not only settled well into the Wealden countryside but still maintains strong links with the City of London where its fine marching band is a notable attraction on Lord Mayor's days. Within the nearby church of the Holy Innocents at Southwater a series of stained glass windows depict the history of the school over the centuries, a scene from one of the windows being shown here.

Opposite: The view from Sharpenhurst Hill between Itchingfield and Barns Green looking south towards the distant South Downs.

One of the interesting features of the Low Weald is the series of old trackways or droving roads that in many cases run north to south linking early centres of habitation at the foot of the chalk escarpment with what were outlying swine or other pastures in the then mainly uncolonised High Weald. Many of these trackways date back to the Saxon period where by a system of land division most of the unsettled Weald was allotted to each of the manors between forest and sea. In places they now function as part of the present road system but in other instances have reverted back to green ways which can only be discovered on foot. Often the trackways are as broad as 10–13m with high bordering hedgebanks whilst elsewhere they form deep hollowed routes through the clay. The photograph shows part of the old drove road that once ran from the Wealden pastures south via the outskirts of Barns Green and Shipley through the Findon Gap to West Tarring.

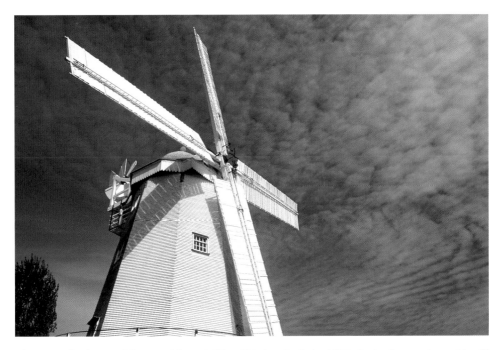

Almost at the heart of Sussex, Kings Mill at Shipley, built in 1879, is the largest 'smock' mill in the county. It was purchased in 1906 by the great Sussex writer Hillaire Belloc and has now been restored to full working condition in his memory.

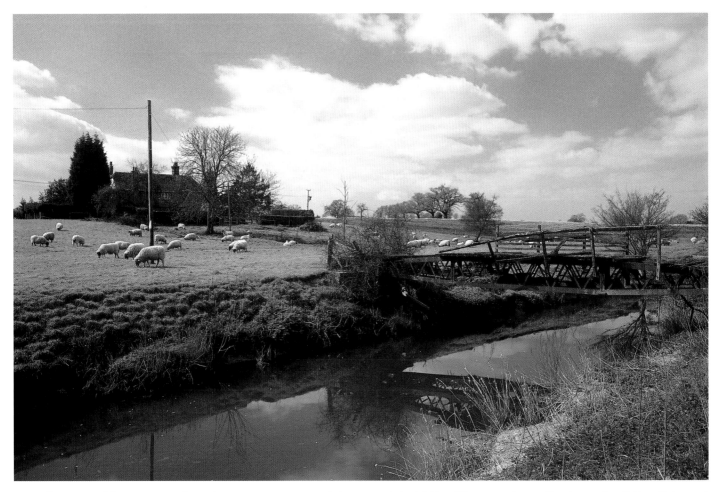

Typical Low Wealden countryside in the empty areas around the upper Adur Valley. The scene immediately south of West Grinstead Church shows in the foreground the remains of part of the old Baybridge Canal, one of the least known and insignificant waterways in Britain being only some 6 km in length. A canalised river navigation, it was completed in the 1820s to serve Baybridge Wharf adjacent to the present day A24 main road.

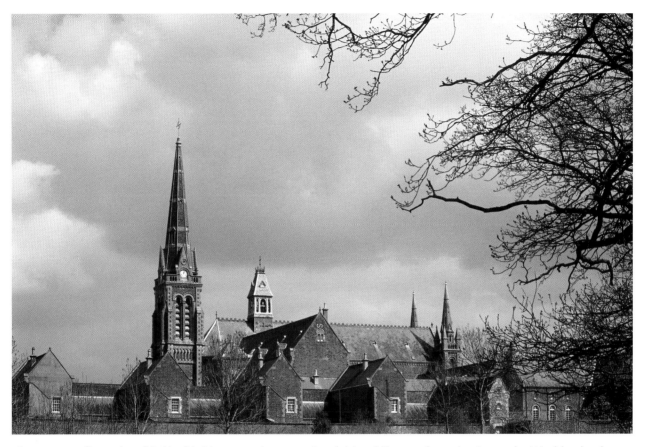

The commanding spire of St Hugh's Monastery between Cowfold and Shermanbury dominates the Wealden landscape for miles. A Carthusian order, the only one in England, the monastery was built between 1875–83 to accommodate up to 80 monks being expelled from France. Comprising an outer courtyard leading to the chapel and an enormous cloister behind with the monks' cells opening on to it, the entire structure is built in a French Gothic Revival style.

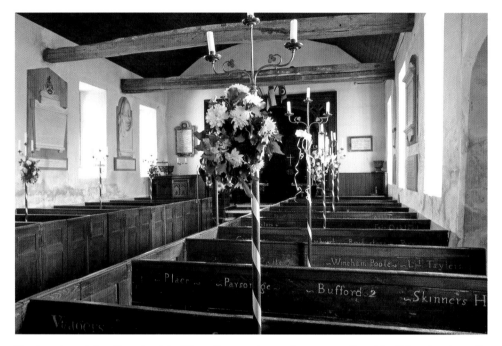

The interior of the Church of St Giles, Shermanbury. Once a medieval building but heavily altered in restoration, the church still contains box pews with house and farm names painted on, similar to those at the nearby church of St George at West Grinstead. A carved wooden chancel arch and Royal coat of arms of Queen Anne are also featured. Ewhurst Manor with its moat and medieval stone gatehouse lies to the north whilst to the south the Mock Bridge extension of the Adur Navigation reached a wharf alongside the Cowfold to Henfield turnpike.

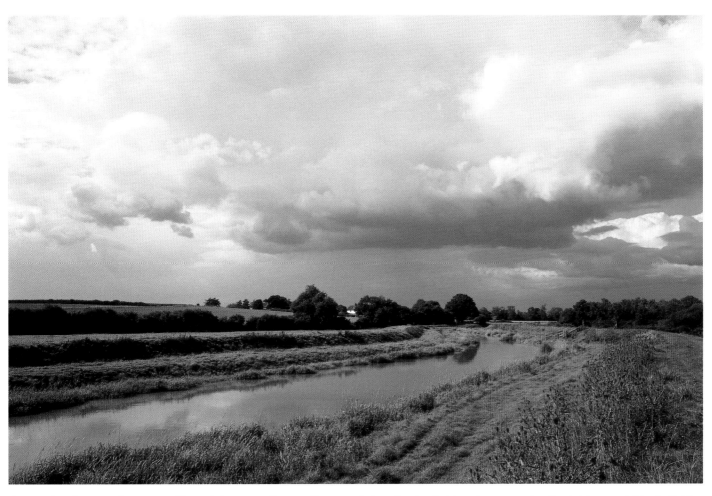

Storm clouds over the upper River Adur near Eatons Farm and the river's division between the Baybridge and Mock Bridge extensions. This area is one of the most sparsely settled and tranquil parts of Sussex where the edge of the flood plain is still lined with farms, some of which acted as inns when barge traffic on the Adur Navigation was considerable in the first half of the nineteenth century.

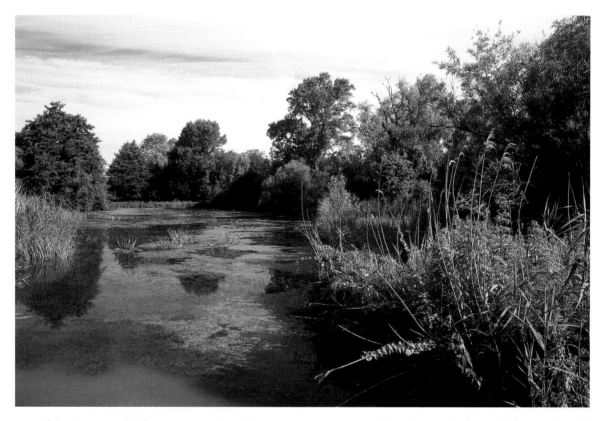

Part of the Sussex Wildlife Trust's Woods Mill nature reserve near Small Dole, south of Henfield. Woods Mill, the headquarters of the Trust donated to them in 1966, has been converted into a museum where much of the machinery can still be seen and where considerable emphasis is placed on wild life exhibits. Outside a series of convoluted nature trails wind their way around the Trust's ponds with several facilities for observing the hidden life within. During each year the Trust hosts a whole series of events at all of its managed reserves across the county featuring numerous activities and lectures on a wide range of natural history topics.

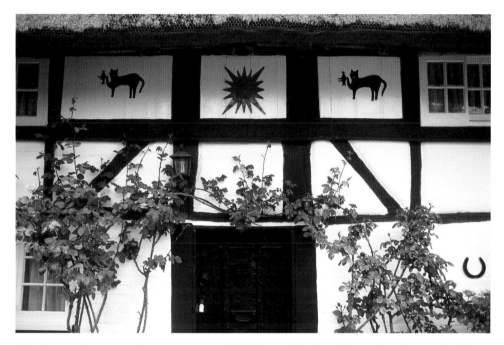

The sixteenth-century Cat House at Henfield is possibly the village's best known building. The thatched cottage featuring a series of cats with birds in their claws and acting as bird scarers was apparently the owner's way of protesting when the local Reverend's cat ate one of his pet canaries. The area around the Cat House is still known as Pinchnose Green probably from the smells once emitted from a nearby tannery.

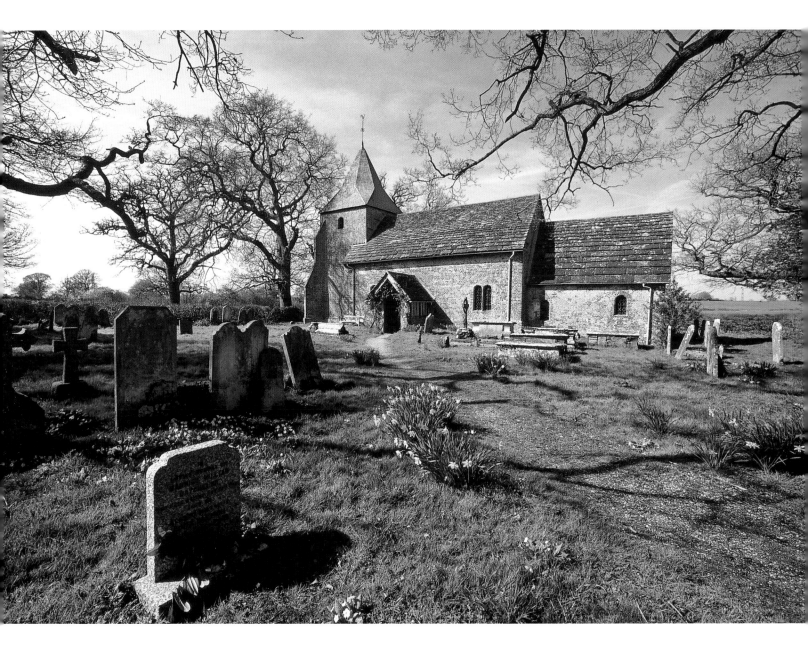

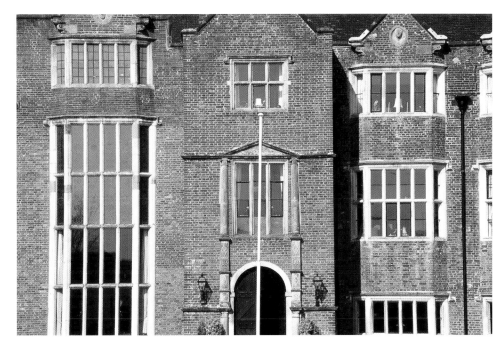

East of the A23 trunk road to Brighton, the Low Weald starts to narrow and the land becomes more built up. This is classic commuting country with easy access to London. The towns of Burgess Hill, Haywards Heath and Hassocks with their dormitory villages have tended to spill out across the countryside and in places to almost join up with each other. South of Hurstpierpoint near Hassocks, Danny Park House close to the Downs dates back to 1582. The house is now divided into flats and part of the monumental east front is shown here.

Opposite: The Church of St Peter at Twineham sits alone out in the fields at the end of a lane close to the headwaters of the River Adur. Of early Tudor origin it is built entirely of brick, one of only three brick churches in Sussex, with a Horsham stone roof. In the churchyard a small plot was unusually given over to the Quakers in the late seventeenth century and is now marked by stones.

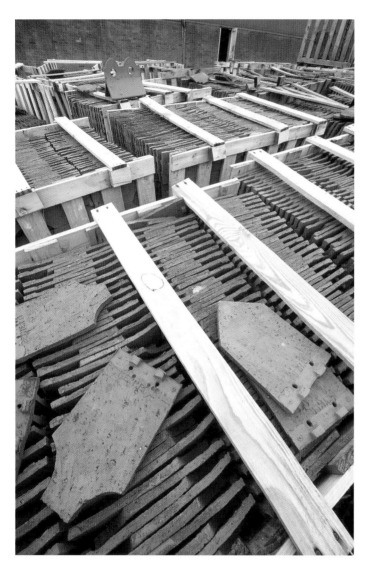

The immensely varied geological foundation of Sussex reveals itself on many of the older buildings by the use of local building materials. Brick and tile making clays were particularly plentiful in the Weald, each local site tending to produce products under different conditions causing considerable variation in texture, tone and colour. Keymer brickworks in Burgess Hill has created hand made clay tiles and decorative roofing products for more than four hundred years, their famous 'Sussex Red' coming from a unique local vein of red clay. The photograph shows crated tiles awaiting collection.

Ditchling. The village of Ditchling, under one of the highest summits of the South Downs, contains many buildings of considerable character and age, one of which was reputed to have been given by Henry VIII to Anne of Cleves. In more recent times the village has also become famous for the artists and craftsmen who have lived there including the well known sculptor, typographer and writer Eric Gill. E V Lucas refers to a conversation with an old lady living in the neighbourhood who, when about to visit London for the first time, was asked what she expected to find, replied "well, I can't exactly tell but I suppose something like the more bustling part of Ditchling".

The view looking north on a fine summer's evening from below the Downs near Plumpton towards East Chiltington and the distant High Weald.

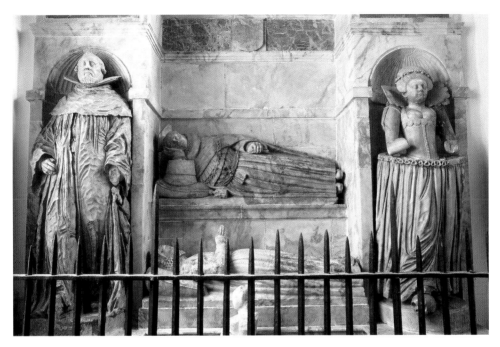

Part of the Jefferay monument of 1612 within Chiddingly Parish Church. The monument is one of only two specimens of funerary statuary in England of the early seventeenth century to contain erect figures and stands in the south transept of the church especially built for the purpose. The monument is to Sir John Jefferay who died in 1578 and was Chief Baron of Exchequer under Elizabeth I. His effigy is shown reclining on one elbow above the form of his second wife Dame Alice. Below them kneels a grand daughter Elizabeth whilst in the niches each side stand Sir John's daughter Elizabeth and her husband Sir Edward Montague. Carved in Alabaster, the monument is thought to be the work of William Cure II, one of a famous family of sculptors who came from Amsterdam in 1541 and worked in England for three generations. This church is one of only three in East Sussex to feature an ancient stone spire.

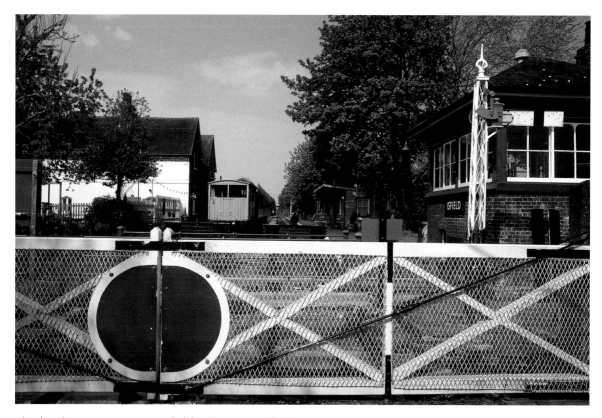

The level crossing gates at Isfield adjacent to Isfield Station mark the southern termination of the privately owned Lavender Line. Now running heritage trains for a short distance north, the line originally formed part of the London, Brighton and South Coast Railway's route from Lewes to Tunbridge Wells closed in the mid 1960s south of Uckfield.

Pleasure boats tied up at the Anchor Inn, south of Isfield on the River Ouse near Barcombe Mills. At one time the river, canalized as part of the Upper Ouse Navigation, contained a group of three mills here the last being destroyed by fire in 1939 leaving only the disused sluices still to be seen today. This stretch of the river is however still very popular for boating where its wide, calm waters meandering through the adjacent flat meadows provide the perfect location for a long lazy summer's afternoon.

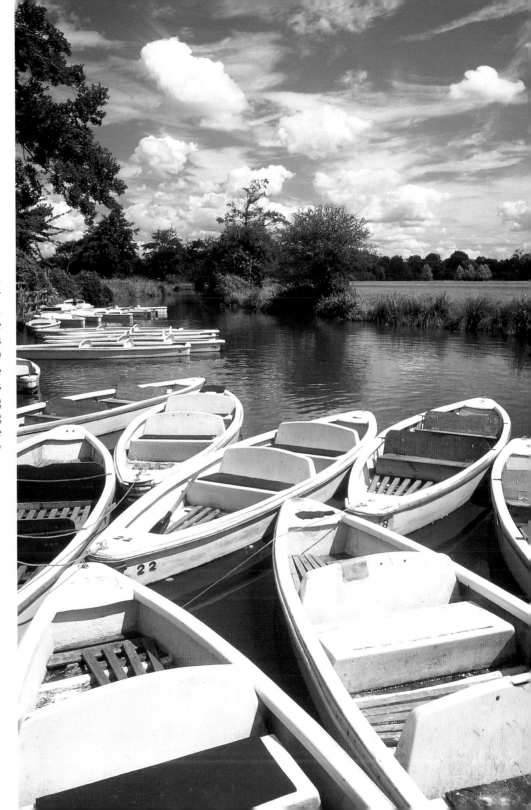

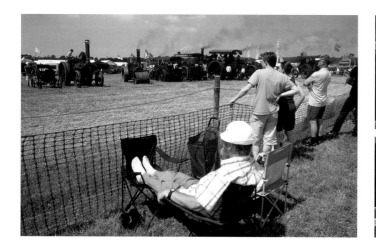

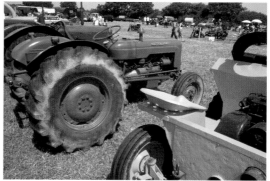

This page and opposite: Scenes at the Ringmer Steam and Country Show. One of the largest events of its type in Sussex, the annual two-day show features displays of steam traction and showman's engines, vintage cars, military vehicles, motorcycles, stationery engines, commercial vehicles and models together with associated craft outlets, fairground and catering facilities. Run as a charitable event for all the family, the show attracts several thousand visitors each year.

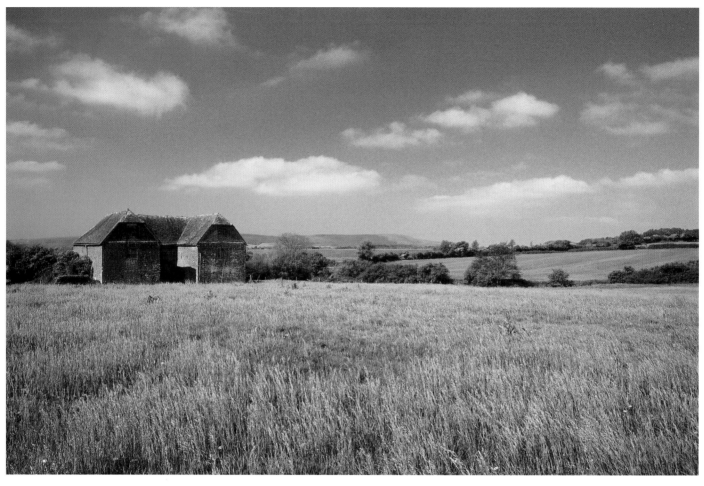

An unusual twin-hipped brick-built barn in open countryside near the village of Arlington on the upper reaches of the Cuckmere in high summer. The South Downs can be seen in the distance.

Springtime at the Arlington Bluebell Walk. Beatons Wood was opened by Bates Green Farm near Arlington in 1972 as a fund raising event for a local primary school. From then onwards and with the help of East Sussex County Council, various walks within and around the wood have been developed and from which local charities now benefit from the numerous visitors paying to enjoy the scenes and particularly the vistas of bluebells in springtime. The deciduous wood is the most southerly block of semi natural woodland on Wealden clay and designated as an ancient site.

Michelham Priory. The original Augustinian Priory was founded in 1229 but largely destroyed at the Dissolution, the remaining fragments being incorporated into a Tudor mansion. Situated on the banks of the River Cuckmere, the property is surrounded by the longest medieval water-filled moat in England and entered via the fourteenth-century stone gate house, part of which is shown here. Now cared for by Sussex Past, many of the buildings such as the watermill and Great Barn have been restored and together with house and grounds are open to the public.

Opposite: The classic view from near Wilmington looking across ripening Wealden fields to the South Downs with the prominent Firle Beacon in the far distance.

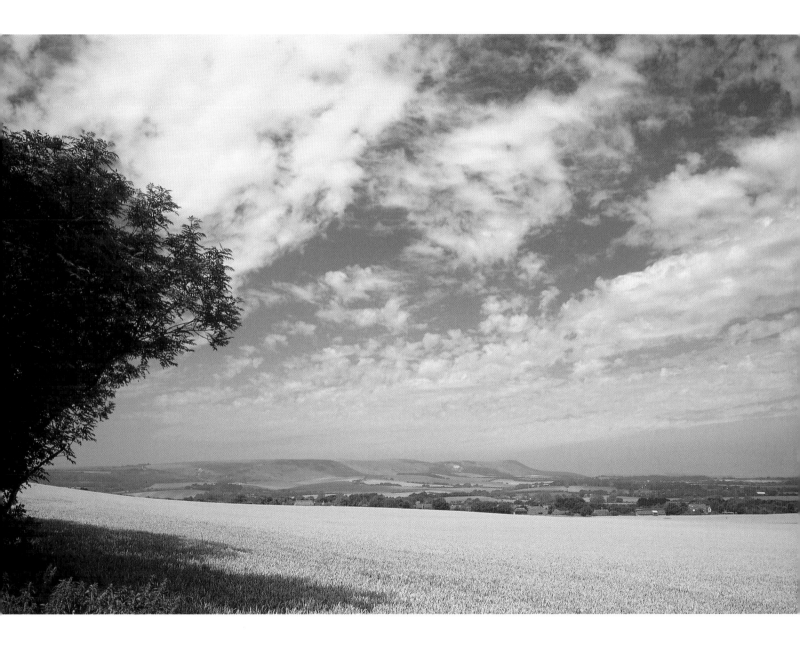

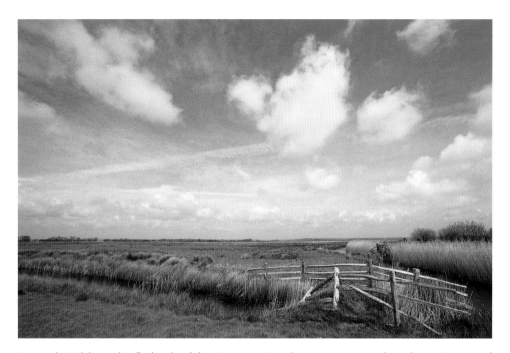

Beyond Hailsham the flatlands of the Pevensey Levels sweep eastwards as far as Hooe and south to the sea. This recovered marshland, the largest in Sussex and the eastern extremity of the Low Weald, was painstakingly reclaimed by opulent abbeys such as Battle, prosperous local magnates and lonely farmers from the twelfth century onwards. Saltmarsh changed to sedgy meadows and ultimately into arable land. By the construction of numerous dykes and surrounding embankments, an extensive patchwork of rich fields and enclosures was gradually formed down the centuries, interrupted at intervals by successive flooding in the Middle Ages, to give the landscape of the levels seen today. The photograph shows a typical levels scene of ditches, reeds and wide open skies neat Rockhouse Bank.

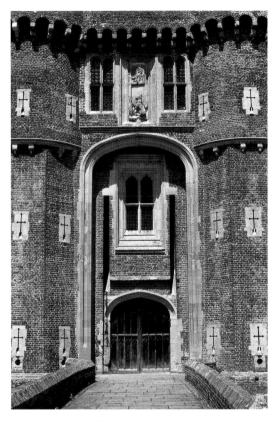

Herstmonceaux Castle. The moated, brick Herstmonceaux Castle set in beautiful parkland on the northern fringes of Pevensey Levels was built around 1441 as a castellated manor house, one of the earliest important brick buildings in England. Becoming the home of the Dacre family for almost 300 years, it was eventually sold, part of the interior was demolished and by the late eighteenth century the castle was a ruin. Restoration commenced in 1913 being finally completed some twenty years later. Towards the end of the 1940s the building became the home of the Royal Greenwich Observatory and now with its modern Observatory Science Centre, it is a popular location to visit.

Part of the ruined and moated Pevensey Castle built in about 1100 by William the Conqueror's half brother, Robert Count of Mortain, within the brick and flint walls of the third century Roman Fort of Anderida. The castle with its gatehouse, keep and three angle towers is a reminder of Pevensey's importance as a port in medieval times long before the sea retreated over 2km to the south. In 1940 when a German invasion appeared likely, the castle was prepared for defensive action with its towers being strengthened with concrete and pill boxes constructed to appear as ancient masonry. Most of the Roman walls, described as the finest Roman monument in Sussex and enclosing an area of some 4ha, still stand.

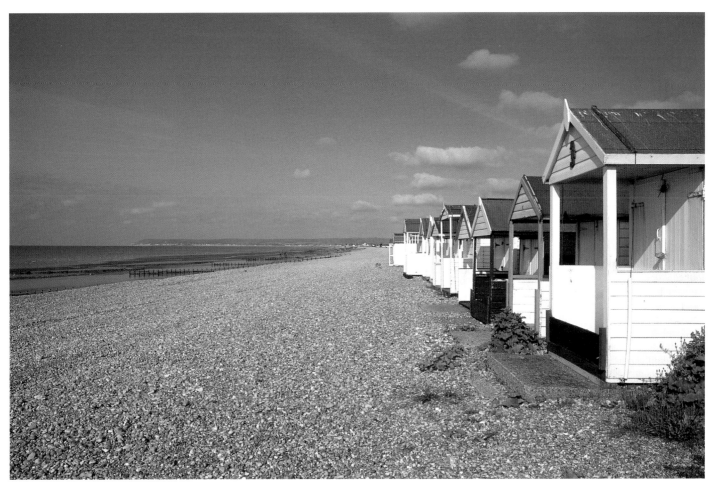

The Low Weald finally terminates on the exposed, sometimes bleak shoreline between Langney Point east of Eastbourne and Cooden on the outskirts of Bexhill. Behind the sand, mud and shingle and numerous breakwaters, the verandahd bungalows and holiday homes of Pevensey Bay and Normans Bay lie scattered along or below the embanked beach. Beyond, the Pevensey Levels extend to the foothills of the High Weald. Several circular brick Martello towers built between 1805 and 1810 as a defence against a feared Napoleonic invasion still dominate the scene. The photograph, taken near Cooden, looks back past a small collection of beach huts along the shore towards distant Eastbourne.

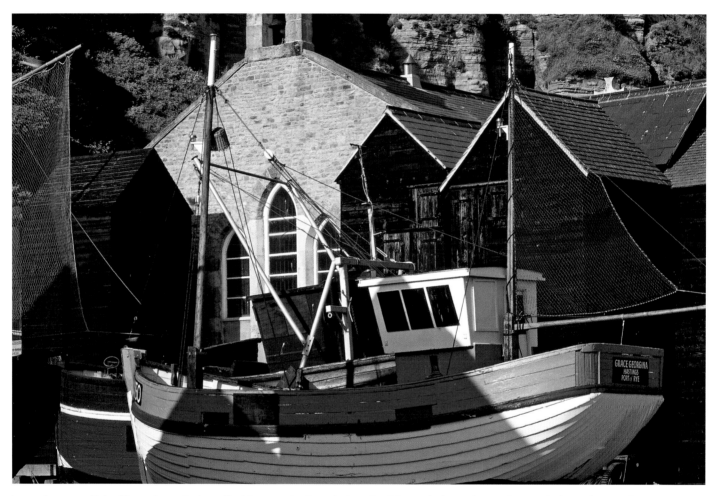

Late afternoon light filters through the tall, thin, weatherboarded and gable roofed net shops clustered along the 'Stade' at Hastings. As one of the original Cinque Ports, Hastings has always had close connections with the sea possessing a large fishing fleet where boats are still drawn up on the Stade's shingle when not in use. The historic old town nestling between two ridges and undulating down to the shore is a fascinating contrast to what is now a principally Victorian resort with a few Regency survivals. Situated literally just a few hundred metres west of the rising ground as the High Weald meets the sea with its exposed sandstone cliffs, Hastings makes an excellent starting point for High Wealden exploration.

THE HIGH WEALD

Hastings to Horsham

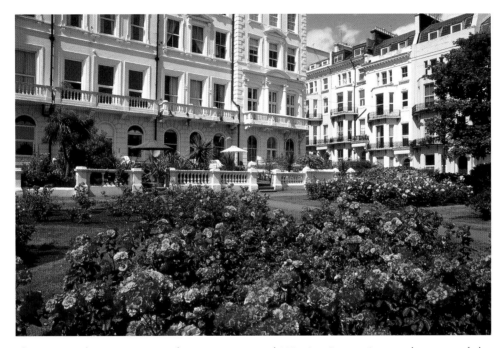

The stuccoed Victorian seaside terraces around Warrior Square just to the west of the modern centre of Hastings.

The hilly High Weald has been described as one of the finest yet least known small-scale landscapes in England. With its still considerable covering of ancient woodland, open heathland and with numerous deep valleys, brooks and streams it is of a totally different character to the Low Weald. From the coast immediately beyond Hastings, the region forms a broad shallow arc stretching back west to the town of Horsham and with its northern boundary extending into Kent. For most people, even in present times, to think of Sussex recalls visions of the South Downs or the well known coastal resorts and therefore the High Weald still posseses to a certain degree a sense of seclusion and mystery.

Fairlight Glen. From Hasting's East Hill the land continues to rise rapidly as the southern end of the Forest Ridge, an extension of the High Weald, nears the coast. Fairlight Church stands at almost 170m, its high embattled tower acting as a landmark for many miles and particularly for mariners up and down the Channel. In Fairlight Glen itself a thin canopy of trees spreads down over gurgling streams and dripping vegetation almost to the water's edge and is the only place in the county where such luxuriant growth can be seen as close to the sea.

Where the Wealden clays reach the sea, the dramatic but unstable sandstone cliffs rise to over 100m, an outstanding location to study the geological evolution of the Weald. The photograph shows typical cliff formations and strata near Cliff End beyond Fairlight.

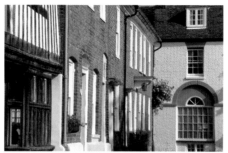
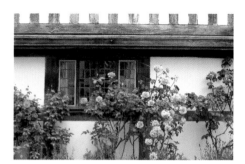
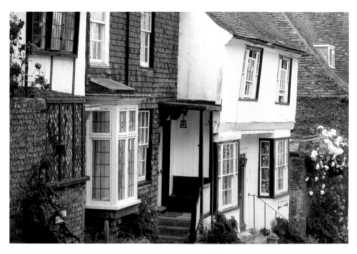
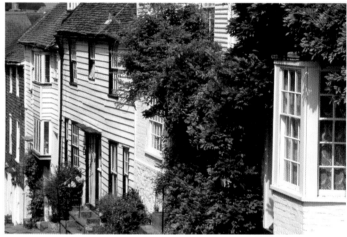

Scenes at Rye. On its isolated eminence adjacent to the Wealden foothills and surrounded by the flat, sedgy marshland of Walland and the East Guldeford Levels, the ancient trading town of Rye has been left almost frozen in time by the sea's retreat to the south. With its outstanding variety of closely packed period buildings lining the often steep and narrow cobbled streets, Rye's rich history is still very much in evidence and in the words of Arther Mee 'is like no other town in England!'

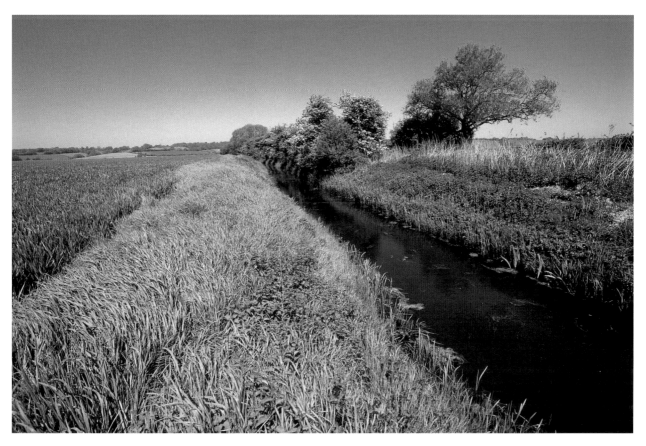

Beyond Rye and near Iden, the land with a scattering of orchards falls away to the Rother Levels and the Kent boundary. The levels at one time would have been submerged by the sea providing access for ships using the numerous now inland wharves and quays, their names on a modern day map giving immediate clues to the history of the area. This is a scene on the levels overlooking the rich reed and willow lined pasture lands towards Kent and the Isle of Oxney.

Queen Elizabeth's Oak. At Northiam a plaque on this ancient Oak tree situated at the top of the green celebrates one of the village's proudest moments:

"Queen Elizabeth I as she journeyed to Rye on 11th August 1573 sat under this tree and ate a meal served to her from the house nearby. She changed her shoes of green damask silk with a heel of 2½" high and a sharp toe at this spot and left them behind as a memento of her visit. They are still in existence and shown on special occasions. The Sussex saying that 'our Oaks are a 1000 years living and a 1000 years dying' suggests this tree could be over 1000 years old."

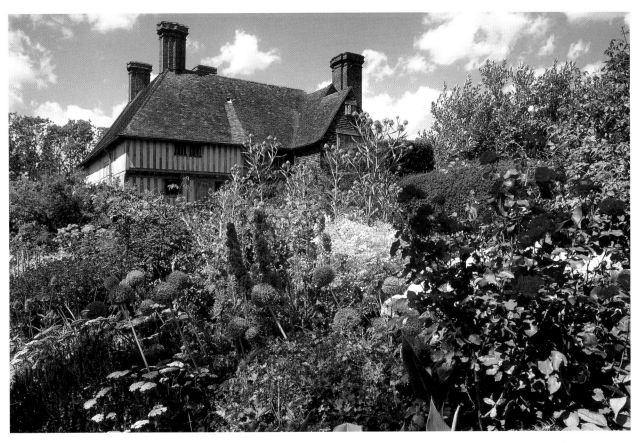

Great Dixter. The fifteenth-century manor of Great Dixter near Northiam was purchased by Nathaniel Lloyd in 1910 and restored and extended under the guidance of the architect Edwin Lutyens, partly by the addition of a medieval hall house moved from Benenden in Kent. The surrounding gardens were also designed by Lutyens, the planting being carried out by Nathaniel and his wife. Cared for by the late Christopher Lloyd, the gardening writer, the gardens have in recent years become one of the most interesting, experimental and informal gardens in England. Wild meadows are used instead of lawns, there is the famous 'long border' of some 70m, extensive examples of decorative topiary and an exuberant exotic garden. Both house and the constantly changing gardens are open to the public.

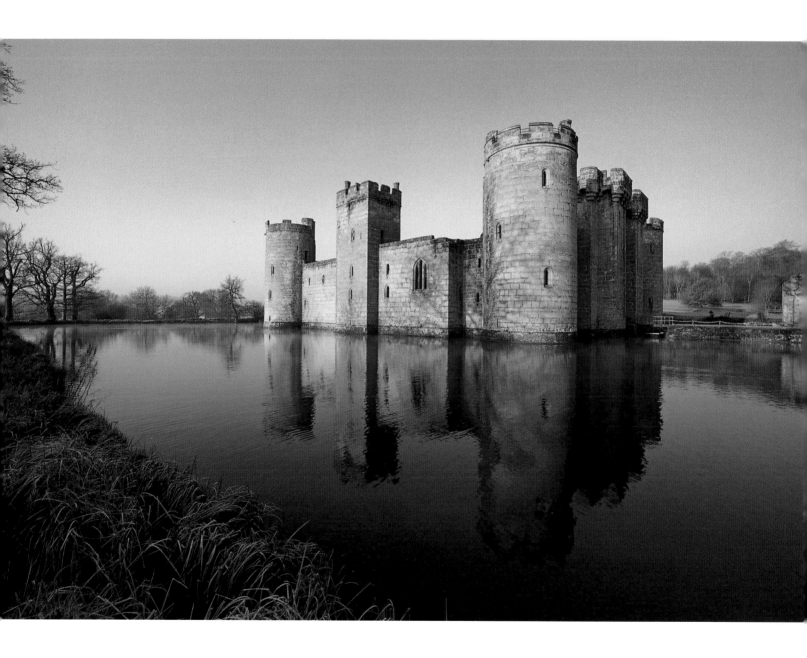

Part of the stained glass 'Doom' window within the sanctuary of the fourteenth-century Church of St Mary at Ticehurst. Described as one of the four top stained glass windows in England, the Doom illustration is made up of fragments of glass dating back to 1452 or earlier. It is a picture of the Last Judgement. Of special note is the cart, pulled by devils, taking the wicked down to hell. In the cart amongst others are figures wearing a crown, a bishop's mitre and a pope's tiara!

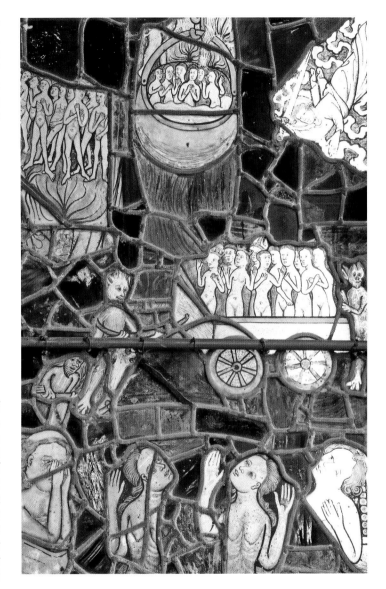

Left: Winter reflections, Bodiam Castle. After the burning of Rye and Winchelsea by French marauders in the late fourteenth century and due to fears of a major French invasion up the estuary of the River Rother from the coast, the romantic Bodiam Castle was built as an additional means of defence of the adjacent countryside. Constructed as a perfect square with massive corner drum towers, the castle in its calm, wide moat has been described as 'the most fairy of English castles'. Never having to withstand attack, the domestic interior was dismantled during the Civil War. Fortunately, however, after purchase in the nineteenth century, the then ruinous exterior was finally restored in 1919 by Lord Curzon and bequeathed to the National Trust.

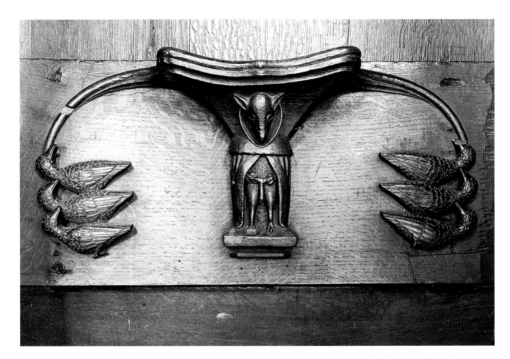

Inside the fourteenth-century Church of the Assumption and St Nicholas at Etchingham are some of the finest misericords to be found in Sussex. From the time of its building, the church was administered by the Cistercian monks at Robertsbridge Abbey as a collegiate foundation which in particular accounts for the long chancel and choir stalls with their nine pairs of misericords. There are nine individual designs of misericord of which *'the fox on column in friar's cloak holding a key and preaching to three geese on each support'* is probably the best known. Misericords are simply wooden brackets below the underside of hinged choir stall seats. When the seat is raised they then act as a support for the occupant when standing. In their semi-hidden environment, they attracted meticulous attention from their carvers, often encouraging a remarkable freedom of expression as in this example. The six geese may be read as members of a gullible congregation in the process of being duped by the fox dressed in a preacher's robe!

Pashley Manor gardens were first opened in 1992 and brought to their present splendour with the help of the landscape architect Anthony du Gard Pasley. They offer a sumptuous blend of romantic landscaping with imaginative planting, fine trees, springs and large ponds. The Tudor manor itself dates back to 1543 with its Georgian façade overlooking the gardens added in 1720.

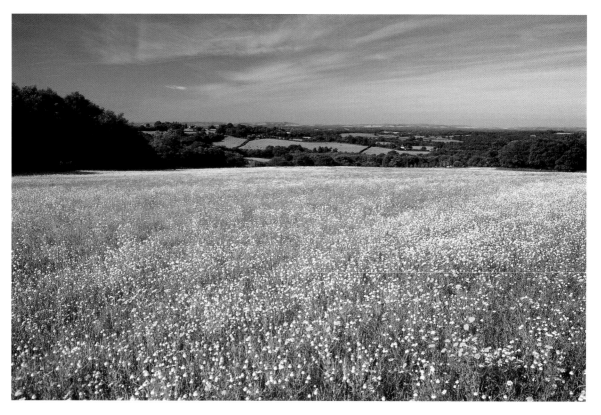

This page and opposite: Brightling. The small hamlet of Brightling stands over 170m above sea level near the crest of Brightling Down, the highest point on the southern Forest Ridge and an area noted for its glorious landscapes and views. Undoubtedly the hamlet's most famous citizen was John 'Mad Jack' Fuller, MP for many years, and an amiable eccentric who delighted in building numerous follies and extravagant structures within the district. Three of these are illustrated opposite.

Above: The view from near the summit of Brightling Down looking over flower covered meadows towards Dallington and the distant Downs. *Right:* A stylised impression of Wealden scenery around the hamlet as demonstrated by a design of a kneeler cover within the church.

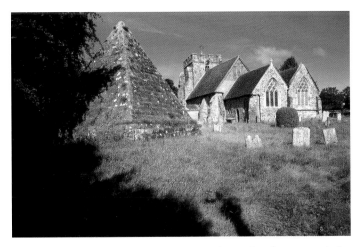

The church of St Thomas Becket with in the foreground the extraordinary stone pyramid which Fuller had built for himself before his death in 1834. He is buried within it.

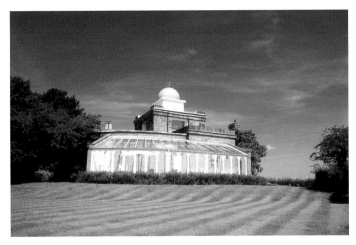

The Observatory with outstanding views over the Weald. Fuller also built a temple in Brightling Park and the nearby Sugar Loaf.

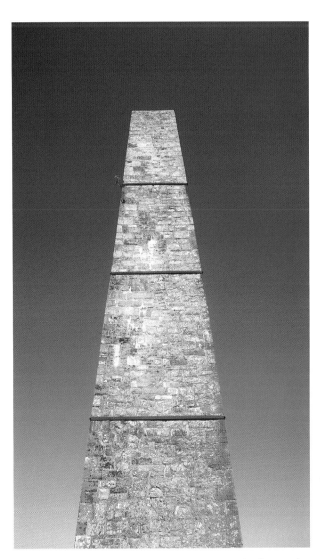

Brightling Needle – a pillar some 20m high on the summit of Brightling Down.

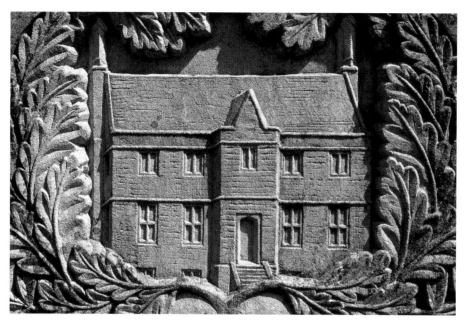

Penhurst. The church of St Michael dating from 1340 together with its neighbouring seventeenth-century manor house form a rare and exquisite manorial group which has remained in this tiny hamlet unaltered for centuries. In this remote region amongst the farms and woodlands of Ashburnham a nineteenth-century report commented that approaches to Penhurst were so difficult in winter that it was almost inaccessible. Within the churchyard a headstone commemorates the life of Paul Broomhall who purchased the manor in the early 1950s and who not only renovated the house but also led the restoration of the church which had fallen into disrepair. An illustration of the Manor, shown here, is carved on the headstone. Penhurst and neighbouring Ashburnham were once famous for their iron industry and from time to time cannon balls made here can still be unearthed. Ashburnham furnace was the last to be worked in Sussex closing in the 1820s.

Opposite: The Monk's Common Room, Battle Abbey. The Abbey was founded by William the Conqueror as an act of thanksgiving for his victory in 1066 and as a mark of respect to those killed. It was built with the high altar of the church on the exact spot where King Harold died. Little is now left of the church, destroyed in the Dissolution, but the roofless dormitory block still stands and below it a series of undercrofts of which this common room is one. Here with its vaulted stone ceiling coloured with age over the centuries, a certain spirit still survives of that October day when the battle of English history took place at this very location. Most of the remaining remodelled buildings of the site now form part of Battle Abbey School.

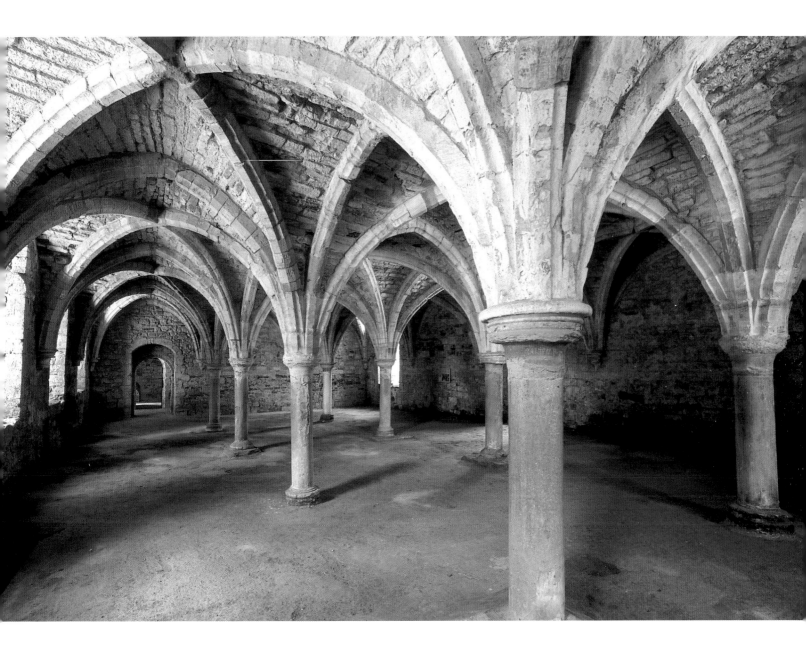

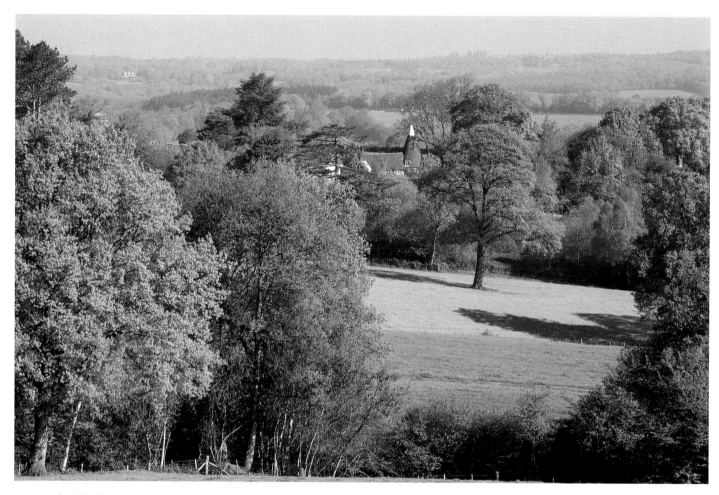

A typical High Wealden view from near Burwash Common in spring looking from the crest of one ridge across to the next with the infant River Rother in the valley below. As is so often the case in the High Weald, the profusion of trees tends to mask many potential long distance views. Instead one simply obtains the odd glimpse here and there with a nearby farmhouse or oast house adding variety to the scene.

Bateman's, Burwash. The Jacobean house of Bateman's was built in 1634 by John Brittan, an ironmaster and is particularly well known as the home of Rudyard Kipling from 1902 until his death in 1936. Built of local sandstone, it is a fine example of the prosperity that the Sussex ironmasters enjoyed for a brief period, their houses often surpassing contemporary manor houses. Now owned by the National Trust, the building with its superb gardens is kept as it was in Kipling's time.

An interesting sales board outside a farm at Witherenden Hill.

Details of three Sussex cast iron tomb slabs to be found in the church of St Peter and St Paul at Wadhurst. There are some thirty of these slabs within the church dating from 1617–1790 indicating the importance of the iron industry in this area and at this period. Singular examples of such slabs can also be found in many other Wealden churches.

'Harmer' plaques. In several East Sussex Wealden churchyards, headstones can be found with delicately designed terracotta tablets or plaques inset into the stone. These were produced by Jonathan Harmer, son of a Heathfield stonemason, from the late eighteenth century until his death in 1849. Varying in colour from a buff to bright red, they are found in a variety of different designs, three of which are shown here.

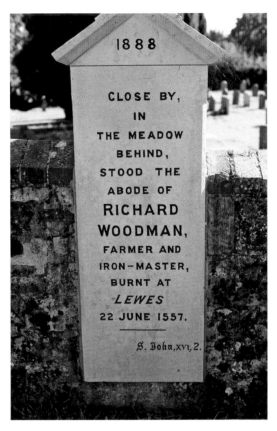

1888

CLOSE BY,
IN
THE MEADOW
BEHIND,
STOOD THE
ABODE OF
RICHARD
WOODMAN,
FARMER AND
IRON—MASTER,
BURNT AT
LEWES
22 JUNE 1557.

S. John, xvi, 2.

In the churchyard of St Mary at Warbleton, just east of Heathfield, this headstone commemorates the nearby home of Richard Woodman who was burned at the stake in Lewes in 1557. Woodman was a Protestant martyr who according to legend accused his rector of being a Protestant under Henry VIII and a Catholic under Mary.

A scene at the Mayfield May Fair in 2008. The fair was revived in 2007 after a fifty year interval and all monies received have been used for village purposes. Mayfield described by the nineteenth-century poet Coventry Patmore as 'the sweetest village in Sussex' was for four centuries the centre of England's largest iron working area. Farming has also been important to the village with some local farm records dating back to the thirteenth century and it is from this background that the spring fairs came into being until the tradition faded in the 1950s. At one time much of the land in the district was owned by the Kings of Wessex but later granted to the See of Canterbury after which for hundreds of years visiting Archbishops used the old palace, the fifteenth century gatehouse of which can be seen in the background of the photograph. With the reinstatement of the fairs it is hoped to revive a tradition that has very nearly gone from memory.

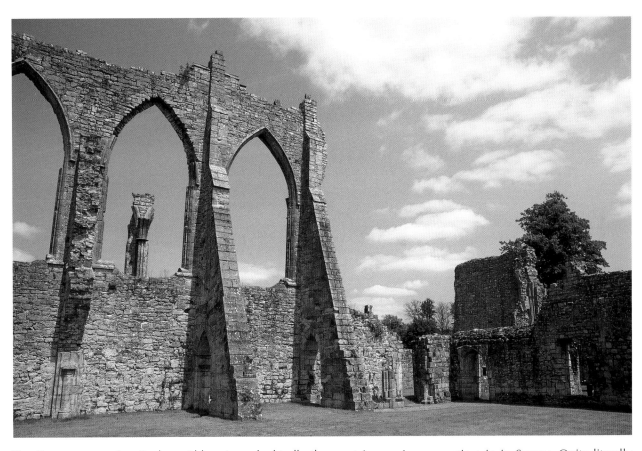

The Premonstratensian Bayham Abbey is undoubtedly the most impressive monastic ruin in Sussex. Quite literally straddling the Sussex/Kent border near Tunbridge Wells, the Abbey was built between 1208 and 1211 with gatehouses in both counties. In 1525 the monastery was suppressed to fall into a romantic ruin, which over the succeeding years, was used as a centrepiece to the landscaping of the immediate area by local landowners. Amongst these was Lord Camden who used the services of the designer Humphrey Repton during the nineteenth century. The Abbey is now in the care of English Heritage.

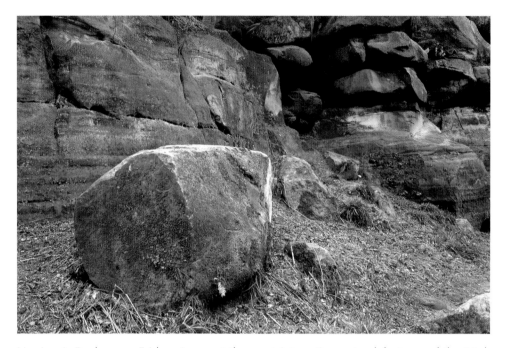

Harrison's Rocks near Eridge. Amongst the most interesting natural features of the High Weald are the exposures of sandstone often to be found rising from the upper sides of valleys and appearing as buttressed cliffs or crags for heights of up to 20m. In places the stone has been weathered to smooth, rounded profiles whilst elsewhere the rock can be found deeply fissured and undercut at its base. It is thought that in some locations the rocks would once have acted as shelters for Wealden hunting parties since evidence of human occupation has been found dating back to at least 4000 BC. Other such exposures include High Rocks near Tunbridge Wells and Hermitage Rocks at High Hurstwood.

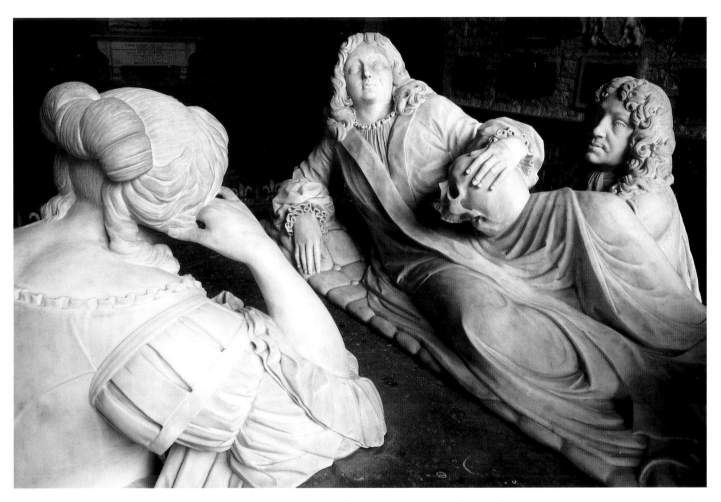

Part of the Sackville monument, Withyham. The monument within its own dedicated family chapel, constructed in 1680 and forming part of the rebuilt Church of St Michael, celebrates Thomas Sackville who died in 1677 at the age of thirteen. Described as one of the noblest works of art in England, the freestanding Baroque design in the centre of the chapel by Caius Cibber carved in white and grey marble shows the boy reclining and holding a skull whilst his grief stricken parents, the 5th Earl and Countess of Dorset kneel around him. On each side of the tomb are figures of the family's other children, six sons and six daughters, whilst around the walls large decorative tablets commemorate the lives of later members of the family line.

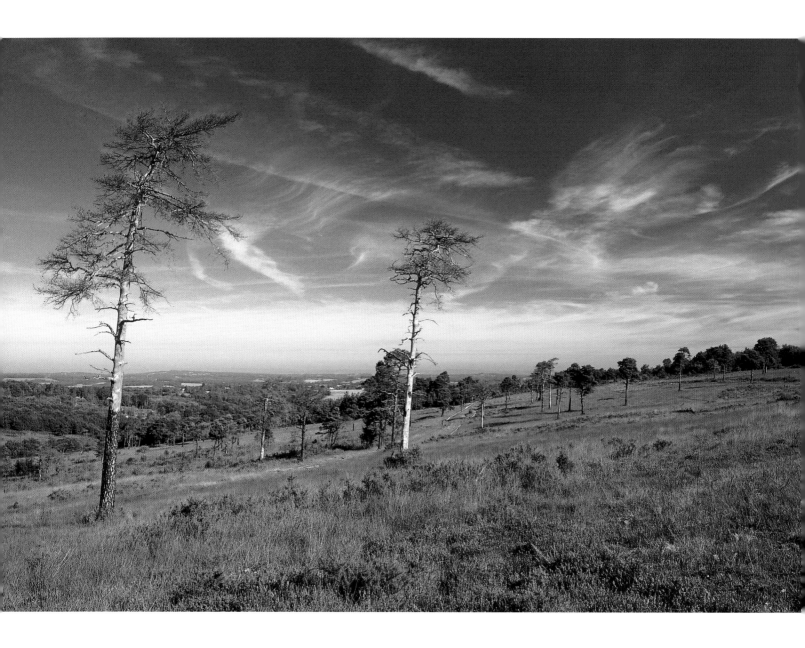

Pooh Sticks Bridge. The writer A A Milne lived in Hartfield on the edge of Ashdown Forest and used much of the Forest as a setting for his characters of Winnie the Pooh and friends. Just south of Hartfield a track crosses a small stream by a wooden bridge and it was here, now known as Pooh Sticks Bridge, that Milne placed Winnie the Pooh for his immortal game. A memorial to Milne and his illustrator E H Shepard is sited at Gills Lap.

Opposite: Ashdown Forest near Gill's Lap. Referred to as one of the few surviving vestiges of primeval England (Peter Brandon, *The Sussex Landscape*), Ashdown Forest is an open region of high ground covered by isolated Scots pine, bracken, gorse and bell heather, broken only by enclosed areas of varying forms of wood and farmland. A decree of 1693 recognized commoners rights by preserving much of the forest as common grazing, awarding an area of some 2600 ha for the purpose and therefore creating the foundations of the landscape to be seen today. William Cobbett described the area as 'verily the most villainously ugly spot I ever saw in England!'

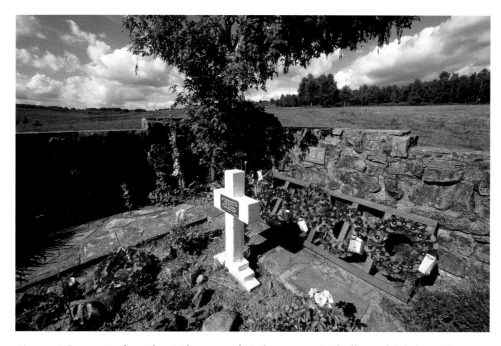

Airmans' Grave, Nutley. About 2km east of Nutley in a quiet hollow of Ashdown Forest, a small enclosure with a white stone cross marks the site where a Wellington bomber from 142 Squadron, struggling back from a bombing raid on one engine, crashed in 1941 killing all six of its crew. The cross was erected in 1954, the wall and a plaque a few years later but every year on Remembrance Sunday a service is held around the grave to remember the young airmen who were killed and all those who continue to die for their country.

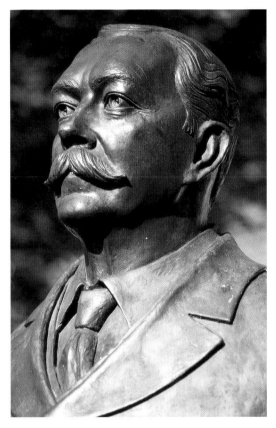

Crowborough is particularly noted for its glorious position adjoining the Forest, the beacon in the centre of the town marking the highest point of the High Weald at 240m above sea level. The description of 'Scotland in Sussex' has been used on more than one occasion to describe the town's surroundings whilst its other claim to fame is that the author Sir Arthur Conan Doyle lived there for the last 23 years of his life from 1907. This statue at the town's centre has been erected in his memory.

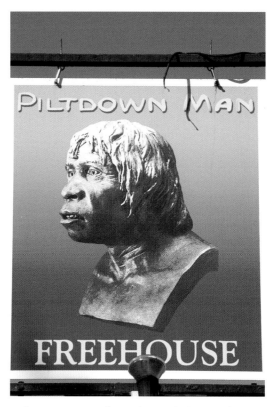

The Piltdown Man. For forty one years the earliest inhabitant of East Sussex was thought to date back to the Pleistocene period. Fragments of a skull were allegedly found between 1910 and 1912 on Piltdown Common near Fletching, these later becoming known as the Piltdown Man. In 1949 the bones were subjected to fluorine tests and some four years later it was announced that the jaw of the skull was in fact that of a young orangutan and virtually none of the finds had come from Sussex. As a result the Piltdown Man became recognised as the biggest hoax ever created upon the archeological community. His memory is recalled by the name of the local pub.

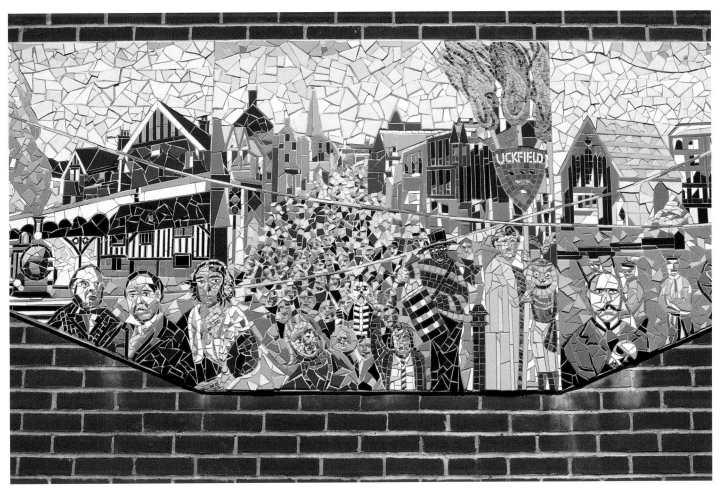

The town of Uckfield has in recent years been represented by its new 'Uckfield Mosaic' on display near the town's High Street. Designed by Oliver Budd, the mosaic was installed in July 2001 as a gift to the people of Uckfield from the members of the Uckfield & District Chamber of Commerce. The photograph shows part of the mosaic mounted on its supporting wall.

Sheffield Park Gardens. From the late eighteenth century onwards, the appearance of the Weald started to change through the effects of deliberate landscaping. High Wealden heaths were planted with clumps of Scots pine and the commons with conifers, the heavy, often acidic clays being particularly suited to the growth of trees and shrubs. Many of the wealthy landed gentry started to create magnificent gardens around their country homes and those at Sheffield Park, laid out by 'Capability' Brown for the first Earl of Sheffield, were some of the earliest. Later remodelled at the start of the twentieth century, the 50ha gardens are amongst the finest of their type in the country with many exotic species in a lakeside setting overlooked by the house itself, designed in 1775. These internationally renowned gardens are now in the care of the National Trust and are particularly colourful during the autumnal season.

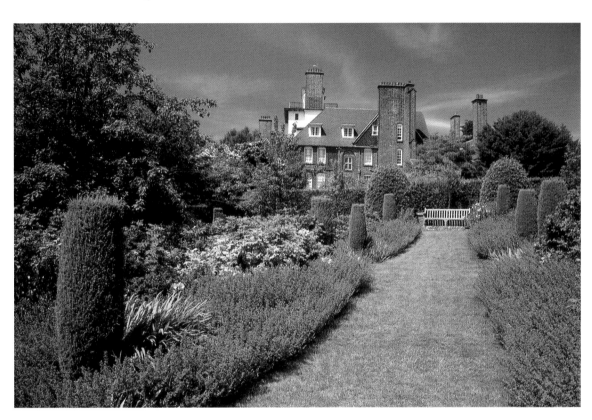

Standen House near East Grinstead was built in the early 1890s as a country retreat for James Beale and is regarded as one of the finest designs of the architect Philip Webb. With its exterior using many traditional and local building materials, the house's richly furnished interior features original textiles and wallpaper designed by William Morris and pottery by William de Morgan. Often described as a showpiece of the Arts and Crafts movement, the house is also surrounded by beautiful informal hillside gardens and woodland. It too is in the care of the National Trust.

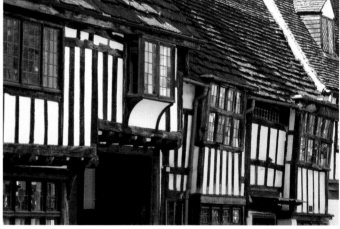

This page and opposite: East Grinstead. Despite ever increasing traffic, East Grinstead's medieval past can still be traced by the layout of its High Street and adjoining properties – an original broad street narrowed in part with an island of buildings which possibly replaced earlier market stalls. The plan of the High Street coupled with the richness of the architecture makes the town centre one of the best examples of its type in Southern England.

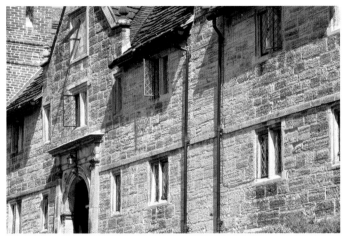

Sackville College, an almshouse founded by Thomas Sackville, 2nd Earl of Dorset in 1619.

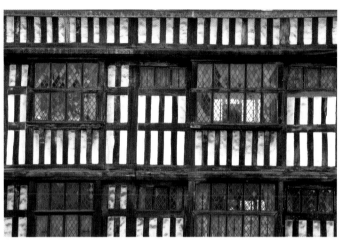

Cromwell House from the early 1600s reflecting the newly found wealth from the Sussex iron industry.

Each side of the street is lined with a delightful variety of period structures, a few of which are shown on these pages, dating back to between the fourteenth and sixteenth centuries.

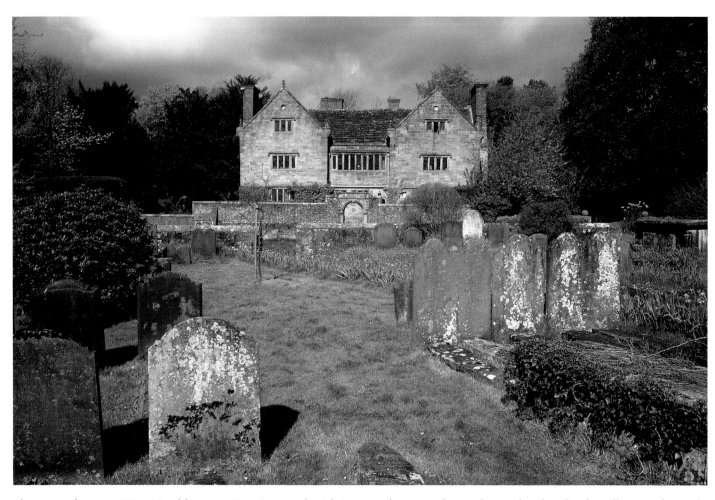

The manor house at West Hoathley, near East Grinstead, with its stone frontage of 1627 facing the church. The village, in the midst of some of the best inland country in Sussex, sits high on a ridge and from its sportsfield toposcope there are spectacular views over four counties on a clear day. Inside the Church of St Margaret are displayed two large cast iron tomb slabs dating from the early seventeenth century commemorating the Infields, ironmasters of nearby Gravetye, together with an immense oak chest hollowed out from a tree and thought to be of thirteenth-century origin.

The timber-framed Priest House next to the manor dates back to the early fifteenth century. It was probably built by the monks from Lewes Priory and like so many of the older, medieval Wealden houses including the manor, it features a roof of Horsham flagged stone. These roofs were often constructed to a relatively steep pitch due to the immense weight imposed on the timber frame. The building was opened as a museum in 1908 and with its traditional cottage garden is now in the care of Sussex Past, the Sussex Archaeological Society.

Travelling south from West Hoathley along Hammingden Lane brings one to the small hamlet of Highbook. The lane slowly undulates along the crest of a ridge with views in all directions to neighbouring high ground and is as good a location as any to appreciate the charm and quiet beauty of the High Weald. Until 1884 Highbrook was within the parish of West Hoathley but its new Church of All Saints, shown here, was built as a result of antagonism within the Church of England and the excessively strict regime of West Hoathley. Constructed on the ridge, the church's tower and spire is a landmark for miles around whilst inside under the shingles a carillon plays delightfully unexpected tunes at various intervals throughout the day.

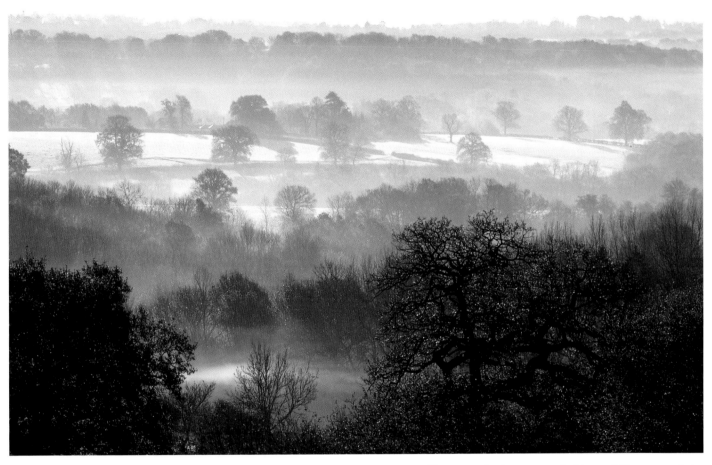

One of the glorious views from Hammingden Lane on a cold frosty autumnal morning looking towards Horsted Keynes and the South Downs in the far distance. The privately owned Bluebell Railway runs through the valley in the foreground on its way north to Kingscote.

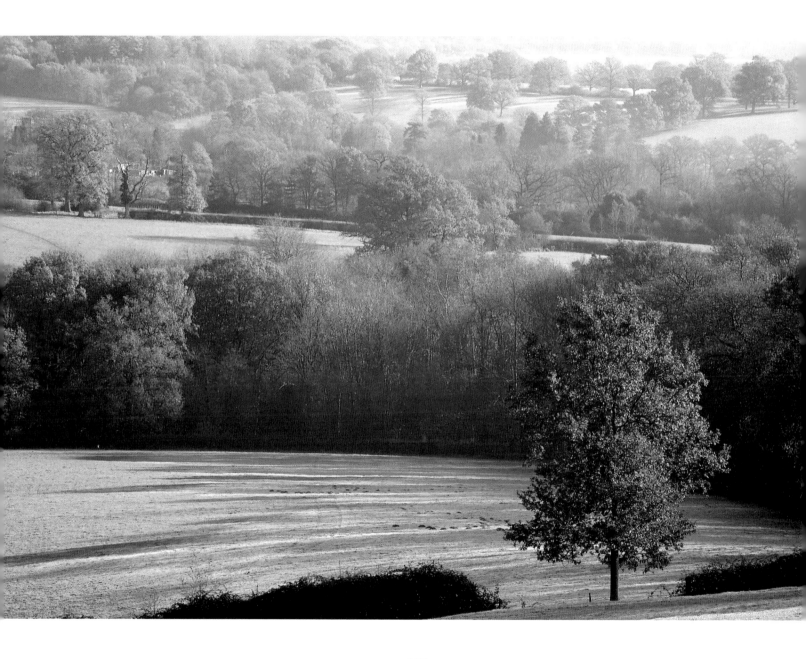

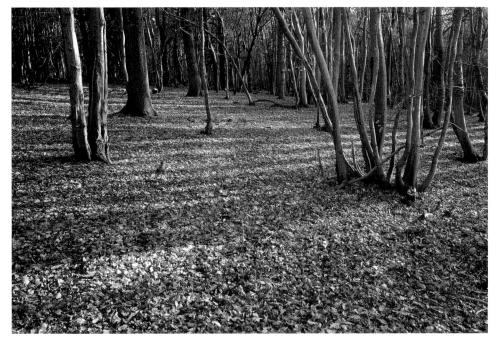

Young woodland near Horsted Keynes in autumn showing signs of earlier coppicing.

Opposite: Typical High Wealden countryside in the vicinity of Horsted Keynes and Cinder Hill viewed from near Highbrook. The number of oak trees visible should be noted, the oak being synonymous with the Wealden scene where it has pride of place in hedgerow, wood and coppice. For centuries oak was used to provide ship building timber, beams for domestic construction, shingles, bark for tanning and acorns for the pigs. Up to two thousand oak trees would be required to build a single first-rate ship of the line in the eighteenth century and therefore a new tree was traditionally planted for each one felled to keep up with this prolific usage over the years. Being indigenous to the sticky Wealden clays, the oak was often known simply as the Sussex Weed.

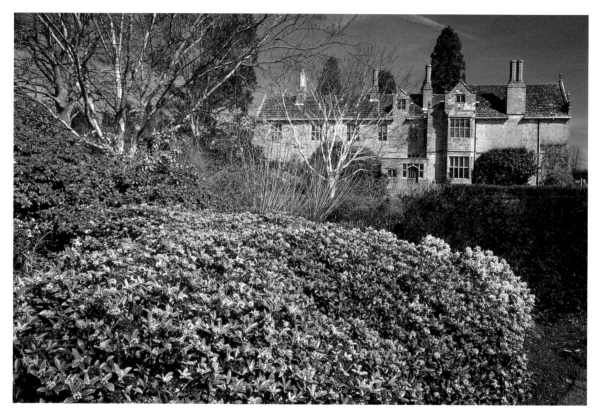

Wakehurst Place. The ornamental gardens in the hilly environment of Wakehurst Place, on a parallel ridge to that of Highbrook, were created by Gerald Loder from 1903 onwards around the much altered mansion dating back to 1590. Containing one of the world's finest collection of plants, many exotic and rare trees and flowering shrubs are featured in areas including a Himalayan glade, water garden, a winter garden, Asian heath, wetlands and extensive woodlands. Bequeathed to the National Trust, the gardens are now leased to the Royal Botanic Gardens at Kew and in particular include the newly constructed Millennium Seed Bank.

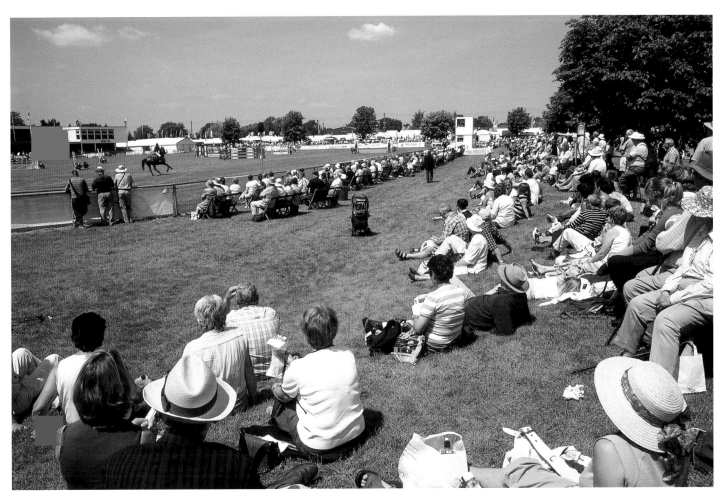

Crowds enjoying the sunshine watch a programme of show jumping at the South of England Show, Ardingly. The village is home to the South of England Showground where the show itself is held each year and where numerous other rallies, fairs, exhibitions and large scale events are also staged. The show provides a popular mix of entertainment over several days including numerous sales, trade and catering outlets and stands; craft, flower and horticultural displays; exhibitions, local society features, farming and livestock demonstrations and all matters of an agricultural nature. There are events held throughout each day in the many arenas and marquees and the entire show becomes an occasion to bring out the sunshine in every sense of the word.

Hammer Pond near Horsted Keynes. The distinctive nature of these ponds has already been referred to earlier. Often only accessible by footpath, these sometimes long, miniature lakes generally bordered by hanging woods are a particular feature found nowhere else in England. Horsted Keynes was once another centre of the iron industry and a glance at the map will show no fewer than twenty one Hammer ponds of varying sizes leading up to Broadhurst Manor and Hurstwood Farm in the woods north of the village.

The Mill Pond at Balcombe.

Wartime Frescoes, Victory Hall, Balcombe. The hall was built in 1923 as a memorial to Balcombe men who had fought and died in the First World War. Around the upper walls are a series of frescoes painted by Neville Lytton based on his experiences of the horrors of trench warfare and as a war correspondent in France. On the north 'peace' wall are portraits of known people, some from the village, including the artist and Lady Denman who had been partly responsible for the instigation of the project. On the south and east walls, the pain, misery, hate and despair of war are depicted – a section of which is shown here – whilst the figures of Dolor and Spes (Sorrow and Hope) appear on the west wall.

Balcombe Viaduct. The coming of the railways transformed Sussex and the Weald opening up many areas hitherto considered inaccessible. The thirty-seven arched 450m long Balcombe Viaduct spanning the upper Ouse valley is one of England's most impressive railway structures. Carrying the London to Brighton main line, the viaduct was completed for the first trains that ran on 21 September 1841. It is hard to believe that many of the twelve million bricks and much of the stone used in its construction were carried by barge up what appears now to be a very small tributary of the Ouse below the viaduct. It is also unusual to find that each pier is pierced and arched both top and bottom. This view from below the massive structure looking through the arched pier openings gives a strikingly symmetrical illustration.

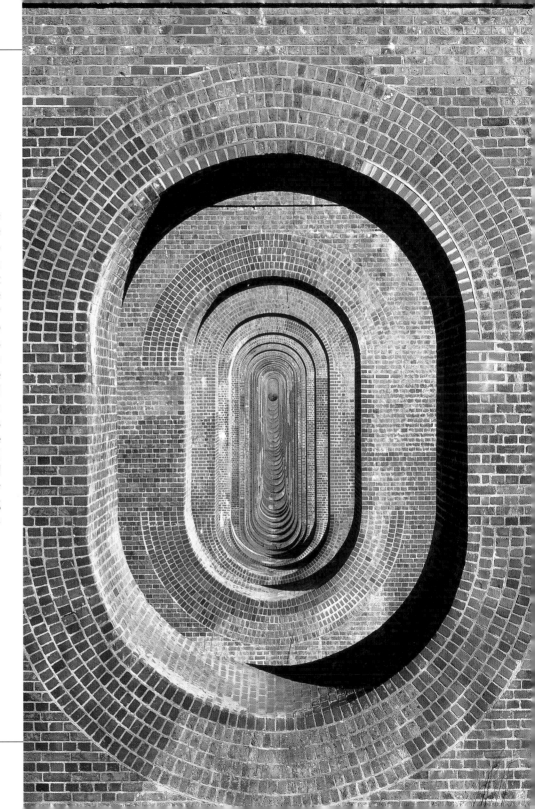

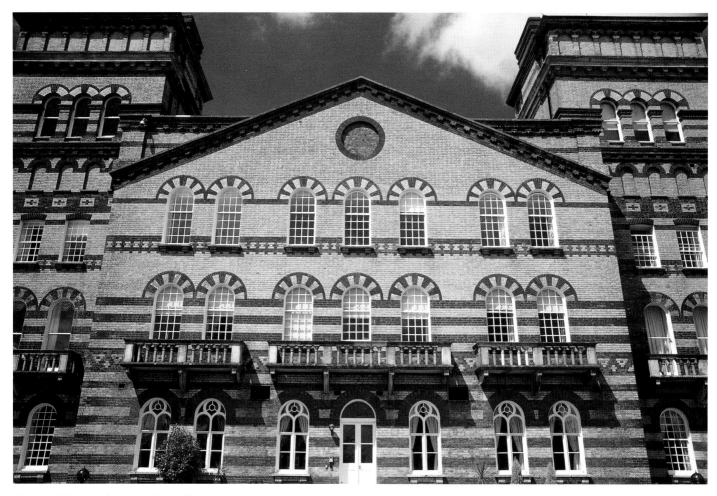

The notable polychromatic brick frontage of Southdowns Park, Haywards Heath. Originally built as the Sussex County Lunatic Asylum and completed in 1859 in the grounds of Hurst House Farm in a commanding position overlooking the South Downs, the Asylum was the largest building project in the county since the construction of Lewes Gaol in 1850. It was designed by H E Kendall in an Italianate style and contained 124 single-bedded rooms and 284 beds in dormitories at its opening. Initially accepting 115 men and 125 women from Bethnal Green Asylum (Bedlam) in London, the new Asylum, later known as St Francis Hospital after 1948, became home to numerous thousands of 'Pauper Lunatics' over its lifetime. By the height of its usage in 1918 the building was accommodating over 1000 patients. With the onset of radical rethinking and treatment of mental health afflictions during the latter half of the twentieth century, the Asylum was finally closed in 1995 to be converted into luxury housing and named Southdowns Park.

Haywards Heath was once a great wild heath (Heyworth's Heath), until the railway arrived in 1841. Comprising a few cottages sited on the edge of Cuckfield Common, the common's enclosure some twenty years later together with the transfer of the weekly cattle market enabled the town to start growing rapidly. Initially some residents commuted to Brighton by train but as the services developed, London became just as accessible. Hillaire Belloc described it as a 'town of the London sort' and in a sense Haywards Heath has always looked towards the capital for its well-being. Mark Anthony Lower in 1870 remarked that Haywards Heath, 'once a byword for the wildness of its aspect', had become 'the abode of civilisation'. After electrification of the railway in the 1930s, the town grew even faster to become known as the capital of Mid-Sussex commuterland where the Southern Railway's modern electric train service was referred to as a 'veritable forty-five minute magic carpet'. The photograph shows part of the wedge-shaped, tree-lined Muster Green, the site of a Civil War battle, on the western fringe of the town.

Queen's Square, Crawley. Despite the 'new town' suffix, Crawley was once a small medieval town and the wide High Street with its buildings dating back to the fifteenth century is an indicator of this period. As an early postwar 'new town' in 1947, it grew rapidly spreading out across the countryside and up to neighbouring Gatwick to create one of the largest urban areas in Sussex. The new town's shopping centre, built immediately adjacent to the old High Street is typical of the 1960s era but the decorative iron bandstand within the square, originally constructed in 1891 at the old Gatwick Racecourse, was re-erected in the square when Queen Elizabeth II opened both the town centre and the new Gatwick Airport in 1958.

As a complete contrast, the World Marble Championships are still held annually at Tinsley Green on the outskirts of Crawley.

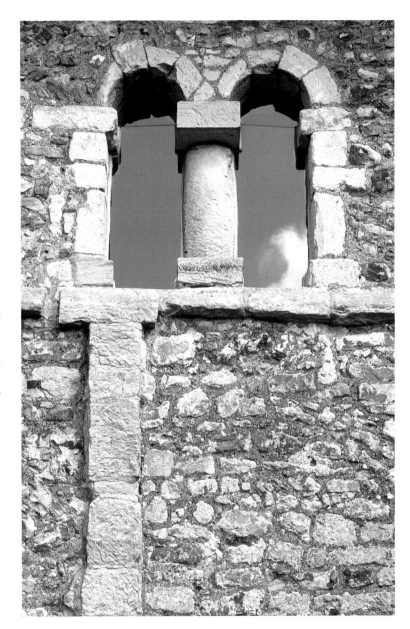

Saxon detailing, Worth. The Church of St Nicholas at Worth is considered to be one of the finest Saxon churches remaining in Britain. Most of the structure has been dated as pre-eleventh century and many of its features such as the pilaster strips, horizontal string courses and the nave windows of two lights divided by a stumpy column are pure Saxon. Within the building the three great Saxon crossing arches are some of the largest to be found. Only the tower and shingled spire have been added later. To enter the church from the bustle of nearby Crawley new town or the clamour of the adjacent M23 motorway is an enlightening experience when time can simply revert back over 1000 years. It is still not clearly understood why such a magnificent church was built in what was a part of the dense Wealden Forest.

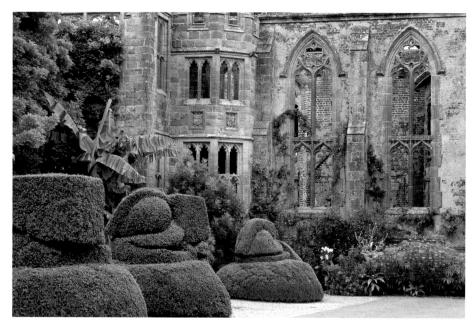

Nyman's Gardens at Handcross, south of Crawley, contain the partly burned-out romantic shell of a pseudo-medieval manor built in the 1920s and destroyed by fire in 1947. The extensive gardens were begun by Ludwig Messel in the 1890s and continued by successive generations of the family with the ruin later acting as a fine centrepiece. Being situated on high ground, extensive views can be obtained towards the distant South Downs. Bequeathed to the National Trust in 1954, many of the garden's fine trees and shrubs were sadly destroyed in the Great Storm of 1987 but since then much replanting has taken place.

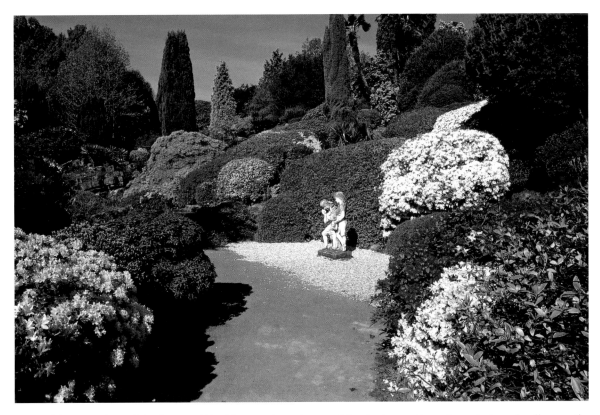

Leonardslee. Another of the famous Wealden gardens, Leonardslee is situated in a deep sheltered valley south east of Horsham and first planted in the early years of the nineteenth century. In 1889 Sir Edmund Loder purchased the entire estate from which the gardens began to take on their present character – an everchanging woodland landscape around a chain of old Hammer ponds and associated waterfalls. The gardens are now among the last great private gardens in England. The photograph shows part of the rock garden, laid out in 1900, with its famous azaleas. Other notable Wealden gardens include Borde Hill near Haywards Heath and High Beeches at Handcross.

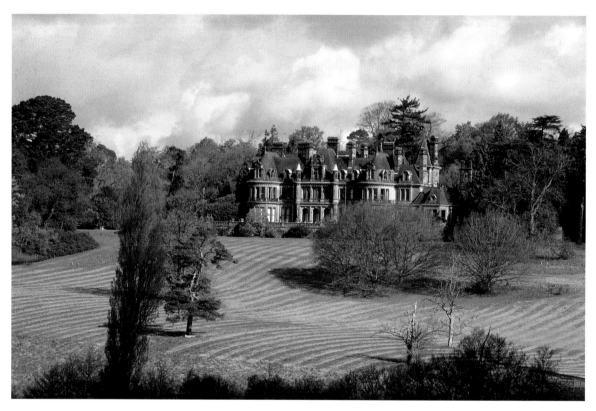

The French-style chateau of Wykehurst high up in the woods north of Bolney. The house with its extravagant turrets, conical roofs and grand staircases was designed by E M Barry for Henry Huth, a banker's son, and completed in 1874. The house was once used as a film set for Hammer Films' horror movies!

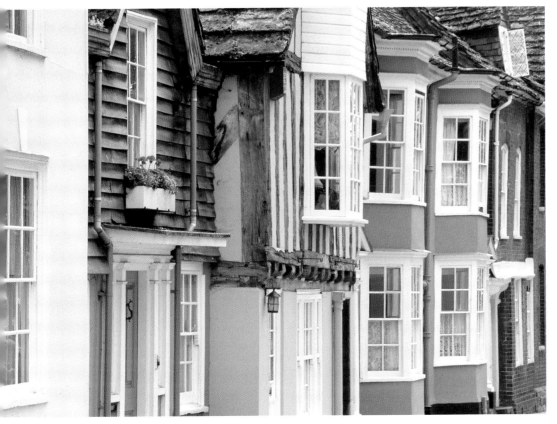

The Causeway, Horsham. In a similar manner to Crawley and East Grinstead, Horsham's past has almost become obscured by modern development and traffic. The Causeway marks one end of what used to be a large, tapering, wedge-shaped green of medieval origins. Becoming an important borough and market town, buildings slowly spread around and across the green's centre leaving one open end to the north to form The Carfax and The Causeway to the south. Leading down to the parish church of St Mary, The Causeway has now become a delightful tree-lined oasis with a succession of period town houses in a variety of local materials and styles along its sides. E V Lucas in *Highways and Byways of Sussex* wrote "There is in England no more peaceful and prosperous row of venerable homes than The Causeway, joining Carfax and the church, with its pollarded limes and chestnuts in line on the pavement's edge, its graceful gables, jutting eaves, and glimpses of green gardens through the doors and windows".

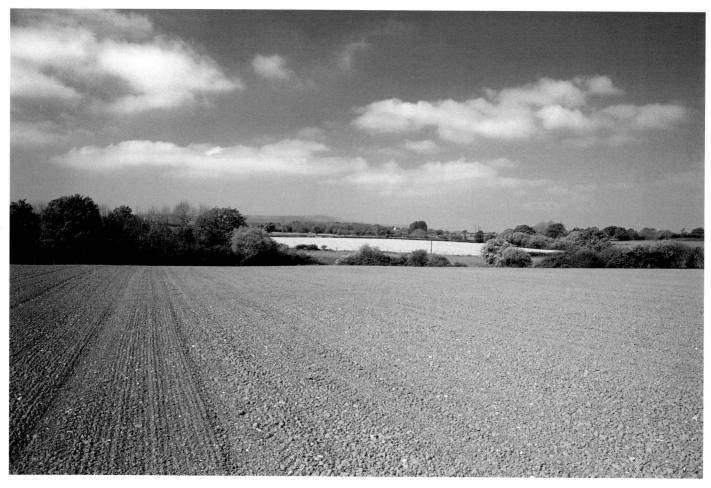

Looking across newly sown fields near the undisturbed twin villages of Ripe and Chalvington, in the flat country of the East Sussex Glynde Levels, towards the distant South Downs.

A WEALDEN MISCELLANY
Bats, Steam, Trugs and Barges

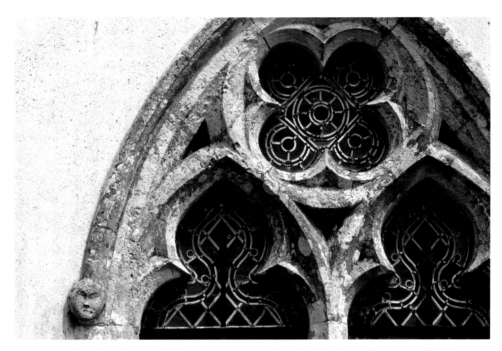

A window detail of the small thirteenth-century church of St Bartholomew at Chalvington.
Note the human head carving as a moulding stop.

Any region of land or countryside is made up of numerous scenes, small details, individual characteristics, distant views or a particular historical background. When added together, all these facets give the area concerned its distinctive, often memorable identity. This final chapter illustrates just a few more of the many miscellaneous factors that create the Sussex Weald to be seen today.

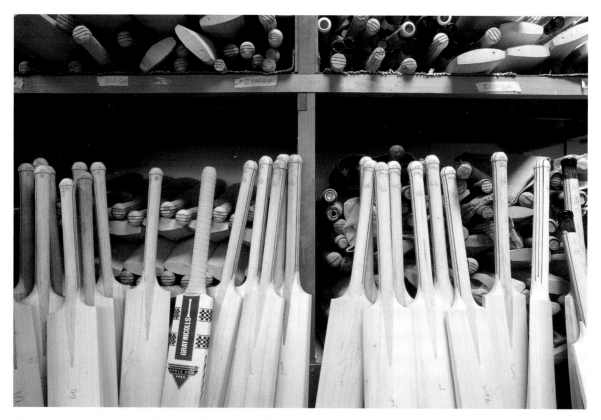

Cricket bat manufacture, Robertsbridge. The village is the home of the Gray-Nicholls cricket bat factory initially founded by L J Nicholls the village carpenter and an enthusiastic cricketer who first started to make bats for friends in the 1870s. Merging with the manufacturer of sports equipment H J Gray & Sons in 1940, Gray-Nicholls have gone from strength to strength and their bats are acknowledged as some of the finest in the market. The handmade bats of English willow and cane require some seventy different stages in manufacture and have been used by famous test cricketers world wide.

A cricket match is played at Ebernoe each year on St James' Day against local rivals Lurgashall to celebrate the Horn Fair. In accordance with tradition, the highest scoring batsman is presented with the horns of a sheep roasted whilst the match is in progress.

The epitome of an English summer's scene at Wisborough Green.

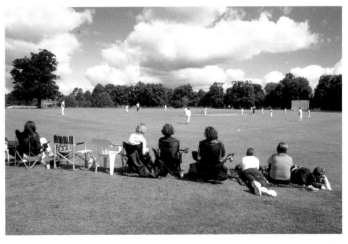

A morning game at Cuckfield with Cuckfield Park House in the background, once described in Harrison Ainsworth's *Rookwood*.

Village cricket.

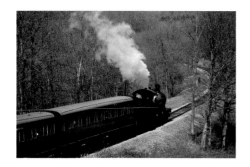

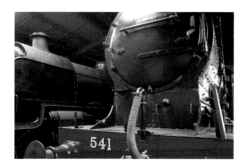

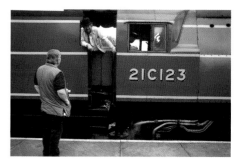

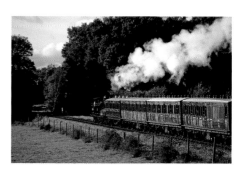

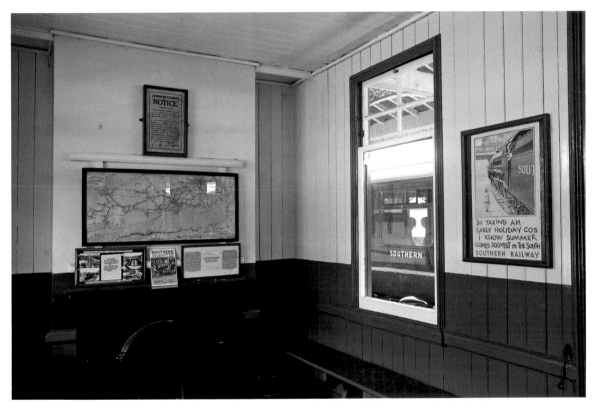

A timeless scene within the interior of one of the waiting rooms at Horsted Keynes Station.

This page and opposite: The Bluebell Railway was founded by a group of dedicated enthusiasts, in conjunction with local inhabitants, with the aim of re-opening a part of the old Lewes–East Grinstead branch line closed by British Railways in 1958. Initially the line was reopened between Sheffield Park and Horsted Keynes Stations in 1960, later reaching Kingscote and with work now well under way for a final return to East Grinstead. As such the railway has become a world famous steam preservation centre and is still the only all-steam standard gauge preserved railway in the country. It is run by numerous enthusiastic volunteers supported by a small group of full-time staff and over the last fifty or so years has carried millions of passengers.

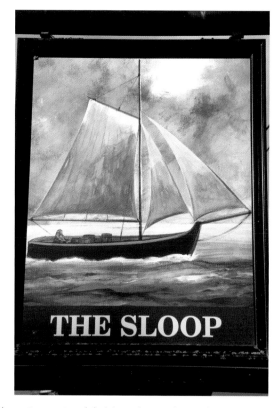

The present day Sloop Inn at Freshfield, within sight and sound of the Bluebell Railway, has been converted from two bargemen's cottages standing near Freshfield lock on what was the canalised section of the Upper Ouse Navigation opened in 1799. At one time many of the Sussex canals would have had inns at regular intervals for thirsty bargees along their banks and The Sloop although much altered is a rare survival.

One of the bridges restored by the Wey & Arun Canal Society as part of the Society's ultimate aim of reinstating navigation on this once important Wealden waterway. This particular brick and stone occupation bridge is sited at Lordings Flood Gate near Lordings Lock on the old Arun Navigation. To date eleven locks, twenty-four bridges and two aqueducts have been repaired or rebuilt and well over half of the twenty-three mile waterway has been cleared with a short section from Loxwood now used for regular cruises.

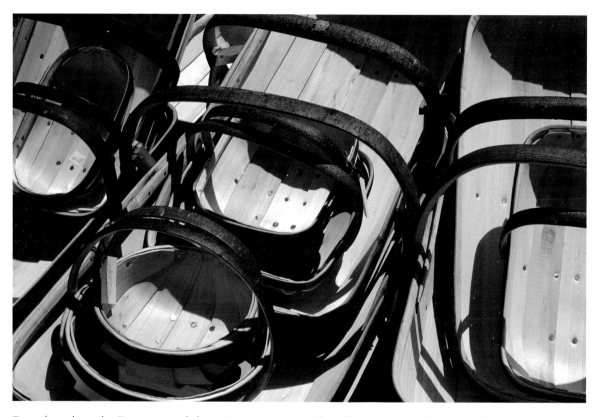

Trugs for sale at the Truggery workshop, Herstmonceaux. The village is generally regarded as the home of the trug making industry, a traditional craft in Sussex dating back over several hundred years. The word 'trug' is possibly derived from the Anglo Saxon 'trog' meaning boat-shaped article. Trugs are baskets of local timber made in a similar fashion to clinker built boats using age-old techniques such as sawing, shaving, soaking and steaming. The baskets are constructed in a variety of shapes and sizes using sweet chestnut and willow. Originally used for agricultural purposes they are now extremely popular with gardeners.

Ditchling Common. To the north of the village of the same name, Ditchling Common is a wide gorse-covered open space with a fine showing of wood anemone in early spring. The common along with so many other Wealden common areas was enclosed in the early years of the seventeenth century. In one corner Jacobs Post is a relic of the gibbet on which a highwayman, Jacob Harris, was suspended after being executed at Horsham in 1734 for the robbery and murder of three travellers.

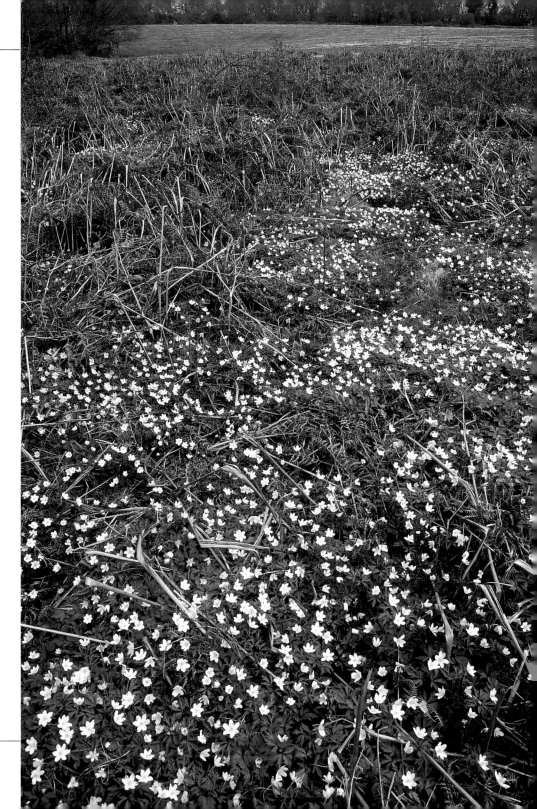

The interior of the Blue Idol Friends Meeting House near Coolham. In this lovely seventeenth-century cottage down a quiet wooded lane, William Penn the founder of Pennsylvania came to speak at Quaker meetings from his home at nearby Warminghurst. Whilst the cottage now serves as a guest house, the small side room with its gallery still acts as a Quaker meeting room and has been used as such since 1691. The name Blue Idol has never been satisfactorily explained but it is thought the house may well have been painted blue during a period of irregular use.

The Cokelers Chapel at Loxwood. Founded by John Sirgood in 1850, the Cokelers or Society of Dependents was a short-lived sect which by the late nineteenth century numbered over 2000 members mainly drawn from poorly paid occupations within the area. Their belief was to follow Christ rather than succumb to any temptations of the flesh such as alcohol, tobacco, music, flowers or even marriage.

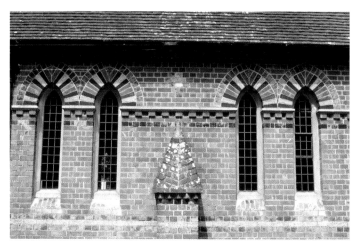

The diminutive brick-built Church of the Holy Trinity at Ebernoe completed in 1867 to help parishioners in the almost inaccessible land of Ebernoe Common.

The Cade Street Independent Chapel of 1767 near Heathfield. In the chapel grounds stands a memorial to the ten martyrs burned at Lewes 'by the Roman Catholics' in 1557.

Wealden chapels.

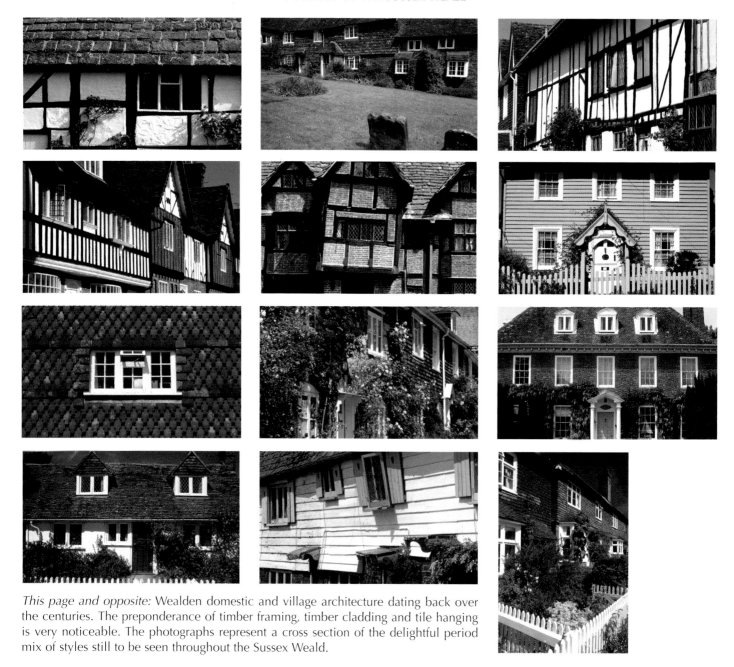

This page and opposite: Wealden domestic and village architecture dating back over the centuries. The preponderance of timber framing, timber cladding and tile hanging is very noticeable. The photographs represent a cross section of the delightful period mix of styles still to be seen throughout the Sussex Weald.

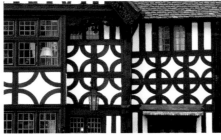
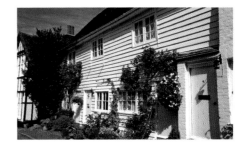
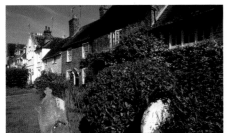

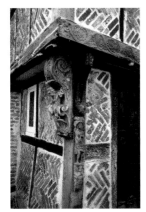

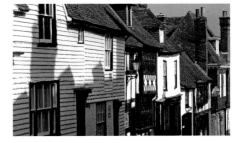

The buildings on these two pages have been photographed at Barns Green, Billingshurst, Cowfold, Cuckfield, East Grinstead, Fletching, Hartfield, Horsham, Horsted Keynes, Kirdford, Lindfield, Mayfield, Ripe, Robertsbridge, Rotherfield, Rudgwick, Rye, Thakeham, Ticehurst, Wakehurst and Winchelsea.

Two milestones at Wych Cross in Ashdown Forest, both indicating thirty five miles from London on the same stretch of road but some half mile apart. As part of the longest sequence of original milestones in the county, these two posts represent changes of distance due to road improvements in the nineteenth century on what is now the A22 trunk road from London via East Grinstead and Hailsham to Eastbourne. Note the variation in design and the allusion to Bow Bells on the stone in the left hand photograph, the location from which the original mileage was measured. As turnpike trusts were formed in the late eighteenth and early nineteenth centuries, many such milestones would once had been erected alongside the improved highways.

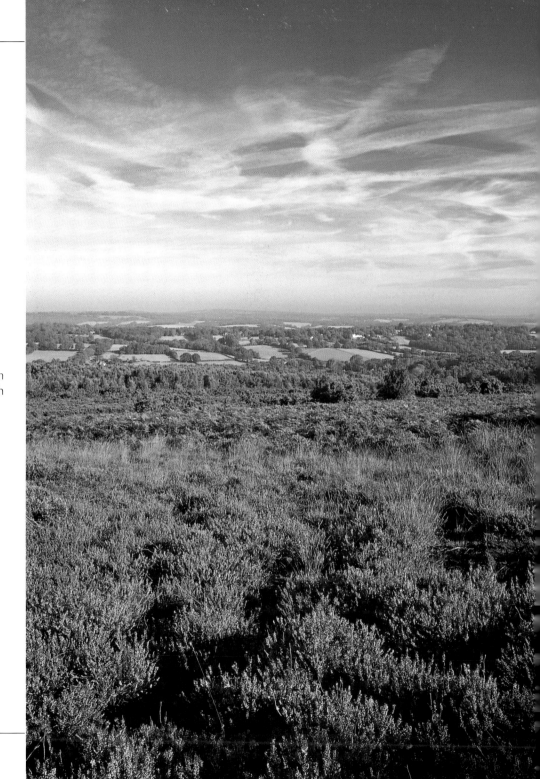

The view from near Gills Lap in Ashdown Forest looking north towards the distant Surrey border.

The quiet and peace of Brightling on a fine early summer's day.

Autumn in Mens Wood. Mens Wood, bordering on to the Low Weald between Petworth and Wisborough Green, is regarded as one of the finest ancient woodlands in Europe and is a remaining fragment of the great Wealden Forest. Its name is derived from the Saxon word 'gemaennes' meaning a common. The wood still contains a sense of the 'dark and impenetrable wild' that earlier writers described of the Wealden scene.

The memorial headstone to Isaac Ingall in the churchyard of St Mary's at Battle, who died at the remarkable reputed age of 120. He apparently served as a Butler to the Webster family of Battle Abbey for over 90 years. A fine testimony to Wealden living.

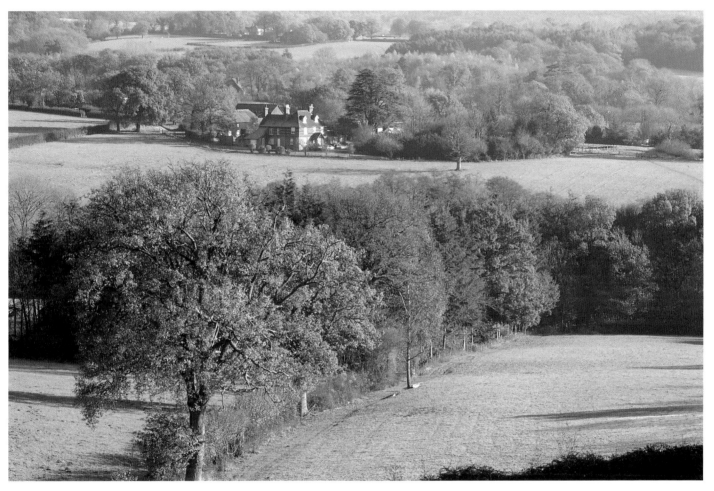

Typical glorious High Wealden scenery looking towards Horsted House Farm from near Highbrook.

'The ancient forest land is still wild enough, there is no seeming end to the heath and fern on the ridges or to the woods in the valleys. The oaks that once reached from here to the seashore were burned to smelt the iron in the days when Sussex was the great iron land. For charcoal, the vast forests were cut down; it seems strange to think that cannon were once cast where now the hops grow and the plough travels slowly, so opposite as they are to the roaring furnace and the ringing hammer'.

Richard Jefferies 1848–1887

ACKNOWLEDGEMENTS

Once again I would like to thank those people who have helped me in the compilation of this book by allowing photography, providing information and for advising on or contributing to captions and text. In particular I am most grateful to the following:

Jean Barnes for allowing the use of the late Tony Barnes' image on page 78; Tony Howard – Director of Southdown Park Management Co Ltd; Pam Malins and the Balcombe Victory Hall Management Committee; Richard Pailthorpe; The management and staff at The Anchor Inn, Barcombe; Bates Green Farm – The Arlington Bluebell Walk; The Blue Idol Friends Meeting House; The Bluebell Railway; the Churches Conservation Trust; English Heritage; Great Dixter Charitable Trust; Gray-Nicholls; Herstmonceaux Castle; Keymer Brick; The National Trust; Pashley Manor Gardens; The Royal Botanic Gardens, Kew; Sussex Past – The Sussex Archaeological Society and The Truggery, Herstmonceaux.

In particular I wish to thank Joy for her infinite patience, support and hard work in typing the manuscript and of course Steven Pugsley and his enthusiastic colleagues at Halsgrove for their faith and assistance.

Finally, thoughts of my late parents who brought me to live in 'The Wonderful Weald' in the first instance. A great start to life!

REFERENCE SOURCES

There are numerous books, booklets, papers, leaflets and guides about the Sussex Weald. It is an impossible task to mention them all but the following have been invaluable as reference sources.

Arscott, D *Curiosities of West Sussex* S B Publications, 1993

Arscott, D *Dead and buried in Sussex* S B Publications, 1997

Arscott, D *A Tour Along the Sussex Coast* Snake River Press, 2008

Barnes, J, Barnes, T and Whiting, J *Misericords in Sussex*
 The University of Chichester 2007

Brabbs, D *Abbeys and Monasteries* Weidenfeld & Nicolson, 1999

Brandon, P *The Sussex Landscape* Hodder & Stoughton, 1974

Brandon, P *The Kent and Sussex Weald* Phillimore, 2003

Brandon, P Sussex Robert Hale, 2006

Bridgewater, P *An Eccentric Tour of Sussex* Snake River Press, 2007

Bruce, P *Northchapel A Parish History* NPC, 2000

Cocking History Group *A Short History of Cocking* SGP, 2005

Collins, S *A Sussex Miscellany* Snake River Press, 2007

Gardener, J *Sweet Bells Jangled Out of Time* Gardener, 1999

Jenkins, S *England's Thousand Best Churches* Penguin Books, 1999

Kipling, R *Rudyard Kipling's Verse* Hodder & Stoughton, 1933

Leslie, K *A Sense of Place* WSCC, 2006

Leslie, K *Sussex – Tales of the Unexpected* WSCC, 2008

Leslie, K and Short, B *An Historical Atlas of Sussex* Phillimore, 1999

Lloyd, D *Historic Towns of Kent and Sussex* Victor Gollancz, 1991

Lucas, E V *Highways and Byways in Sussex* Macmillan, 1904

Magilton, J *Fernhurst Furnace* CDC, 2003

McGowan, I *Moods of Sussex* Halsgrove, 2006

McGowan, I *Moods of the South Downs* Halsgrove, 2007

McGowan, I *Portrait of the Sussex Coast* Halsgrove, 2008

Mee, A *The King's England; Sussex* Hodder & Stoughton, 1964

Mitchell, W *East Sussex – A Shell Guide* Faber & Faber, 1978

Nairn, I and Pevsner, N *The Buildings of England; Sussex*
 Penguin Books, 1975

Swinfen, W and Arscott, D *Hidden Sussex* BBC Radio Sussex, 1984

Talbot, R and Whiteman, R *The Garden of England* Weidenfeld & Nicolson, 1995

Vine, P *The Arun Navigation* Tempus, 2000

Wales, T *The West Sussex Village Book* Countryside Books, 1984

Guides and leaflets to the many attractions, museums, places of interest and churches featured within this book.